IMAGES
of America

COLUMBIA

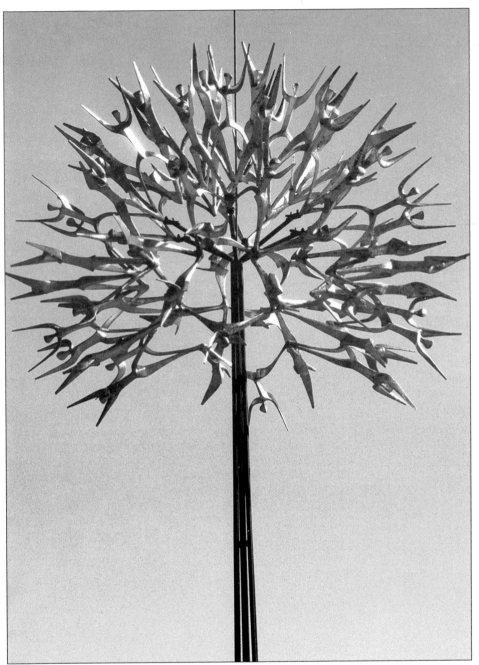

Jim Rouse once said, "I believe that the ultimate test of civilization is whether or not it contributes to the growth of mankind. Does it uplift, inspire, stimulate, and develop the best in man? The most successful community would be that which contributed the most by its physical form, its institutions, and its operation to the growth of people." *The People Tree* is the symbol of Columbia, designed by Pierre du Fayet as the artistic expression of Rouse's vision and the goal that Columbia provide the best possible environment for people to grow as individuals and work together to form a community. The gold-leafed sculpture is the shining centerpiece of Town Center.

IMAGES
of America

COLUMBIA

Barbara Kellner

ARCADIA

Published by Arcadia Publishing
Charleston SC, Chicago IL, Portsmouth NH, San Francisco CA

Printed in Great Britain

Library of Congress Catalog Card Number: 2005920609

For all general information contact Arcadia Publishing at:
Telephone 843-853-2070
Fax 843-853-0044
E-mail sales@arcadiapublishing.com
For customer service and orders:
Toll-Free 1-888-313-2665

Visit us on the internet at http://www.arcadiapublishing.com

CONTENTS

ACKNOWLEDGMENTS

I moved to Columbia about 20 years ago. I knew nothing about Columbia except that it looked like a nice place to live. I began my education, like most Columbians, at the Exhibit Center. Shortly after moving in, I volunteered at Columbia Archives and started reading about Columbia. I never stopped. I thank Rebecca Orlinsky and others on the founding board of the archives for having the vision and the will to begin to collect Columbia's history while it was still very much being written and for giving me the opportunity to direct Columbia Archives. In 1992, Columbia Archives became part of Columbia Association, making it possible for it to grow and better serve the community. I thank the management of Columbia Association for its support and belief that I was the one to write this book. I am grateful to the photographers who gave permission to use their photographs and to all those who have donated materials to Columbia Archives so that they could be shared. All the photos are from the collection.

There would have been no book, of course, without Jim Rouse. He wanted Columbia to be a place for people to grow—to stretch, to challenge, to learn. I learned much about growth and challenging myself and the power of optimism and vision from Jim Rouse. I have been changed by living in Columbia. And I have learned much from the wonderful people I have met through my work with Columbia Archives who were part of Columbia's planning and growth. Bob Tennenbaum, in particular, has been an inspiration and always there to answer questions.

I dedicate this book to all the residents of Columbia who know the vision and have had a part in making Columbia a reality and to those who will learn from the book and be inspired to keep the vision alive.

INTRODUCTION

A full page ad in the *Washington Post* in 1967 pictured a Columbia phone book wedged between directories for Baltimore and Washington, D.C. Columbia had just begun to welcome its first residents. The ad was a promise of things to come—a confident, optimistic pronouncement that an important city would rise from the farmland of Howard County midway between Maryland's largest city and the capital of the United States.

In November 1962, 1,039 acres were ostensibly purchased by Howard Estates. The true buyer, who would not be publicly known for many months, was Community Research and Development (CRD), a subsidiary of the J.W. Rouse Company. The president of both companies was James Rouse, a lawyer, mortgage banker, and pioneering shopping center developer who had a larger vision. He was intent on finding a way to develop an alternative to the growing suburban sprawl, which he found "ugly, oppressive, massively dull."

Working under tight secrecy to conceal his identity and purpose, Rouse acquired about 14,000 acres in the sparsely populated county located in a corridor destined for growth and development. There were rumors about what the press called a "land grab." Residential development was one guess—but there were more outrageous rumors, like the Russians or the United Nations acquiring it. On October 30, 1963, Rouse held a press conference putting an end to the speculation. The intention was to build a city.

Rouse himself had many ideas and many unscientific opinions about cities and how successful communities should be developed. But admittedly, he was not an expert in building cities. One of the key ingredients of the Columbia story is the team of tremendously talented people that he pulled together. He hired William Finley, who, as director of the National Capital Planning Commission, had recently completed a comprehensive report on the future of the region. Finley, in turn, brought in Mort Hoppenfeld and Bob Tennenbaum, architects and planners with whom he had worked. Rouse then connected these architects and planners with educators, sociologists, religious leaders, and experts in recreation, transportation, medical services, government, economics, and more. Informally, this became known as the work group. He told this group to think about the optimums and "Forget feasibility, it will compromise us soon enough." The group dreamed, discussed, and analyzed how basic goods and services could best be delivered to people. Those ideas, studies, and suggestions evolved into plans, sketches, renderings, and reports. This was a very innovative management technique that resulted in some of the most ground-breaking ideas about building communities: everything from interfaith centers, a governance structure, recreational facilities, and childcare, to working with Howard

County to rewrite zoning laws and the school system structure. Four goals that guided all future development also emerged: to respect the land; to build a complete city; to be a place for people; and to make a profit.

The plan was formally introduced to Howard County officials on November 11, 1964. They were shown a three-dimensional model of Town Center and the adjacent villages and given a booklet that described in great detail the plan, the vision, and the promise. The following day, a similar 16-page newspaper insert appeared in the local newspapers.

Construction began in June 1966. Bulldozers carved out lakes and roads and cleared fields for houses, stores, and offices. Architects, planners, engineers, and contractors worked at a frenetic pace. The planning still continued. There was so much to be done. Building a complete city meant aggressively courting those who would bring business, industry, recreation, transportation, and places of worship. It meant working on big ideas and little details. In 1987, Rouse was asked if there were ever a time when he thought it would not work. Rouse relayed a story: "One day I got a call from one of the members of our board who was a banker on Wall Street. He said, 'Are you in trouble in Columbia?' I replied, 'Why, sure, we're in trouble, we're always in trouble. What trouble is it that Wall Street is aware of?' He said, 'We hear that your sewer is being cut off. Is that true?' I said, 'Yes that's absolutely true.' He said, 'What are you going to do about it?' I said 'I haven't the foggiest notion what we're going to do, but we'll solve it.'" And, of course, they did.

On June 12, 1967, an invitation was mailed to those who were most intimately involved in building Columbia as well as a smattering of dignitaries and press. It said, "Work is proceeding somewhat feverishly, on sewer, water, curbs and roads. By June 21 the schedule says the Village of Wilde Lake will be ready to receive visitors. On that day it is our hope that you will join us for the dedication of Wilde Lake and thus mark the opening of Columbia." On June 21, a podium was erected near the shore of Wilde Lake. Men in suits and women in dresses stood or sat on the grass. Rouse took the microphone and said, "This is not really an opening. An opening implies that something is completed. This is really, truly just the beginning. It will be a long time being completed, maybe never, we hope never."

Thus, Columbia "began." Less than a month later, the first residents moved in. In some ways, the real story of Columbia begins at that point—with the people. One of Columbia's goals is to provide the best possible environment for the growth of people. Columbia's symbol, the People Tree, is the artistic interpretation of that goal.

Each year, Columbia marks its birthday with cake, celebration, and the exuberance of youth. It symbolizes the sentiment Rouse espoused during the dedication of Wilde Lake: that Columbia would never be finished. The planners, designers, and builders made certain that buildings and a skeleton of institutions were in place so that those who came to Columbia to live and work could transform the built environment into a community.

In 1968, there was a six-page directory listing emergency numbers, Columbia Association offices, recreational facilities, and the few stores, businesses, and offices that were serving Columbia's first 1,000 or so residents. In 1969, Columbia's first real directory had 24 pages of residential listings. In 2005, Columbia's population is near its original goal of 100,000, and the telephone book can stand up to those of its metropolitan neighbors. Columbia is a major city midway between Baltimore and Washington, D.C. The visionary team, the designers and builders, and the people who moved to Columbia and believed in the promise turned it into reality.

One

A BALANCED COMMUNITY—
A REAL CITY

Let's look at what might be and be invigorated by it.

—James Rouse

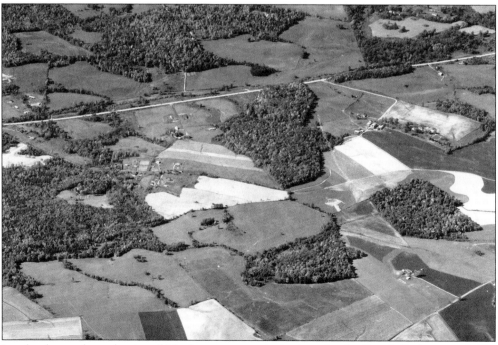

In a land area about the size of Manhattan, comprised primarily of rolling hillsides, corn fields, and pastures, James Rouse saw the promise of a new city. Vision and planning transformed the land and the nature of Howard County.

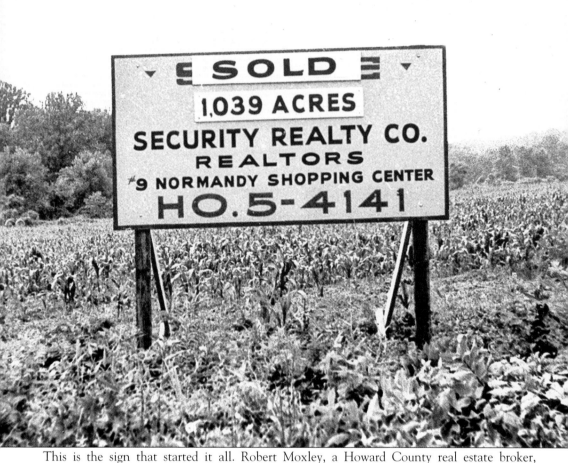

This is the sign that started it all. Robert Moxley, a Howard County real estate broker, convinced four farmers, including his uncle, James R. Moxley Sr., to list their property for sale. Melvin Berman, a board member of Community Research and Development, a Rouse Company subsidiary, saw the sign. A week later, it was the first 1,039 of the 14,000 acres that would become Columbia.

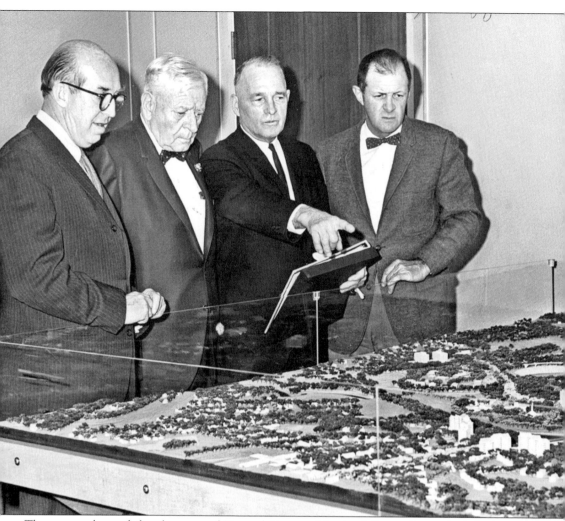

These men changed the character of Howard County, Maryland. James Rouse, far left, shows the model to Howard County commissioners J. Hubert Black, Charles E. Miller, and David W. Force during a presentation of the plan to Howard County officials on November 11, 1964. The commissioners held the power to approve or deny the special zoning request by Howard Research and Development (HRD) to allow for the development of Columbia when the request came up for a vote about nine months later. (Photo by *The Times*.)

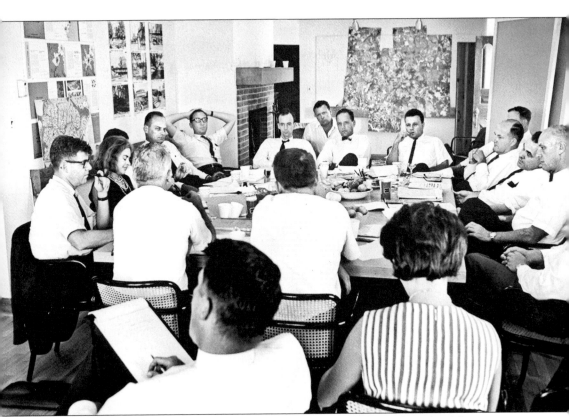

It was called the work group. The simple description belied the credentials of the participants, the intensity of their work, and the long reaching results of their deliberations. The work group included consultants Henry Bain, political scientist; Antonia Chayes, a former member of the President's Commission on the Status of Women; Robert W. Crawford, commissioner of Philadelphia's Department of Recreation; Nelson Foote, sociologist with General Electric Company; Herbert Gans, sociologist from Columbia University; Robert Gladstone, economist; Christopher Jencks, editor of *New Republic*; Paul Lemkau, psychiatrist from Johns Hopkins University; Leonard Duhl, chairman of the Board of Technical and Policy Advisors of the United States Health Corporation; Donald Michael, psychologist and director of Institute for Social Research at the University of Michigan; Chester Rapkin, professor of Urban Planning at Columbia University; Wayne Thompson, a former city manager of Oakland, California; Alan Voorhees, a traffic and transportation consultant; Stephen Withey, psychologist; and James Rouse, William Finley, Morton Hoppenfeld, and Wallace Hamilton, key Rouse Company officials. (Photo by Robert de Gast.)

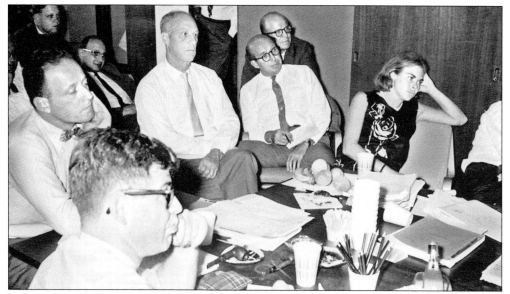

"Let's examine the optimums. . . . Forget feasibility, it will compromise us soon enough," Rouse told the consultants he assembled as the work group. Herbert Gans, forefront, was one of the experts who formed the core group. He had just spent two years studying the suburban development of Levittown, New Jersey; his research was later published as *The Levittowners*.Others at the table from left are Don Michael, Bob Crawford, Jim Rouse, Willard Rouse, and Antonia Chayes.

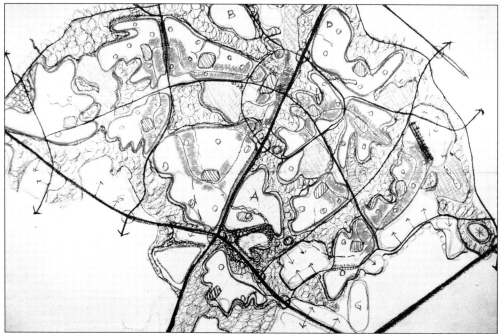

In the corner of this drawing, it says "first sketch shown to Jim Rouse, April 8, 1964." The original measures 56 by 42 inches and is done in green, blue, and yellow pastel crayons, giving it a decidedly child-like, innocent look. It bears remarkable resemblance to the final development plan that was approved by Howard County in 1965.

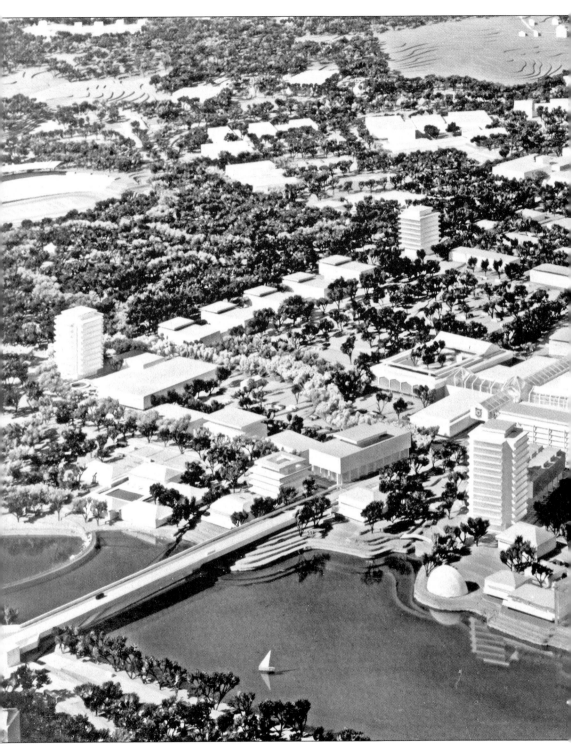

The three-dimensional model was the premier presentation tool. After it made its debut at the formal presentation to Howard County officials, it was placed in a temporary exhibit center that was open to the public. The model highlighted Town Center, the man-made lakes, and the

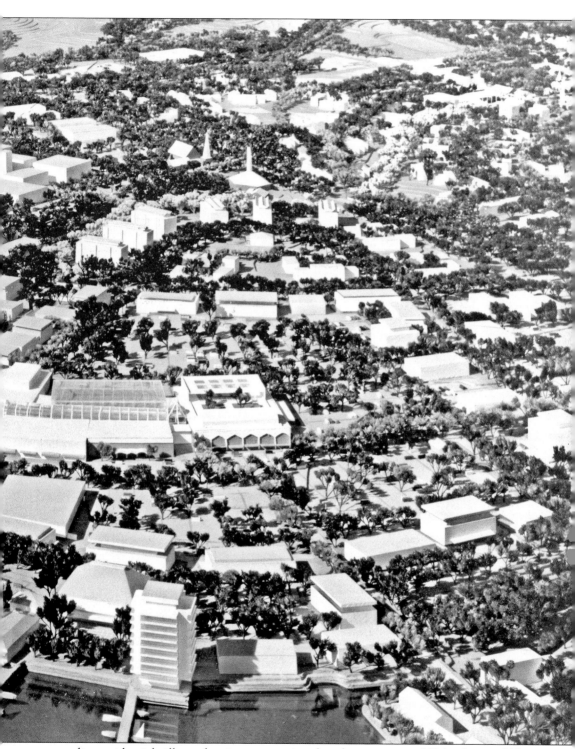

surrounding residential villages, leaving no question that the new town of Columbia would be very different from a typical suburban bedroom community. (Photo by Ezra Stoller Associates.)

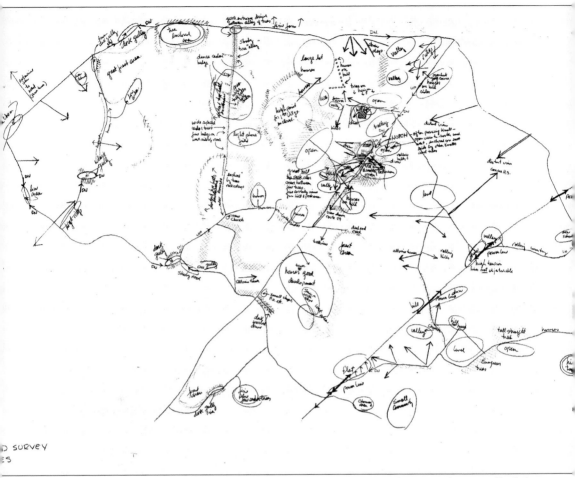

In the very early planning stages, planners Mort Hoppenfeld and Bob Tennenbaum walked the land to note the physical characteristics that could only be seen by close observation. Details like existing hills, valleys, views, and dense cedar hedge as well as possible land uses like "high point for first village" or "large lot houses," were noted in preparation of more precise planning.

16

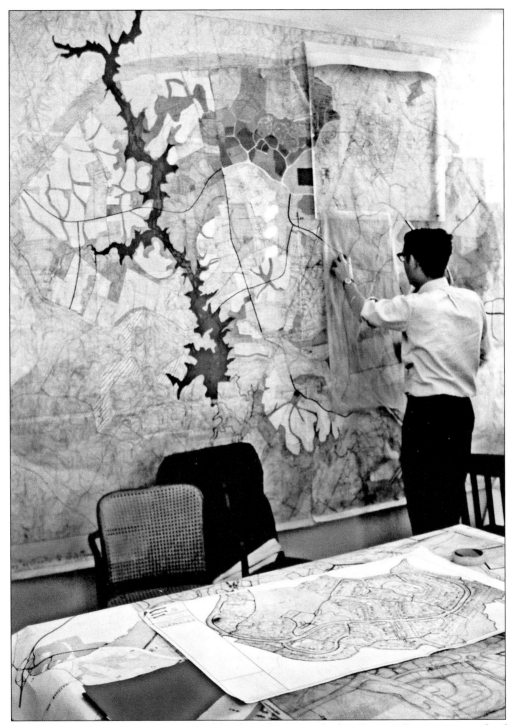

Bob Tennenbaum was 28 years old when he joined the Rouse Company as chief architect/planner working under Mort Hoppenfeld. One of his early responsibilities was land analysis. Here, he works on the wall plan, the base of which was an enlarged 1958 United States Geologic Survey topographic map.

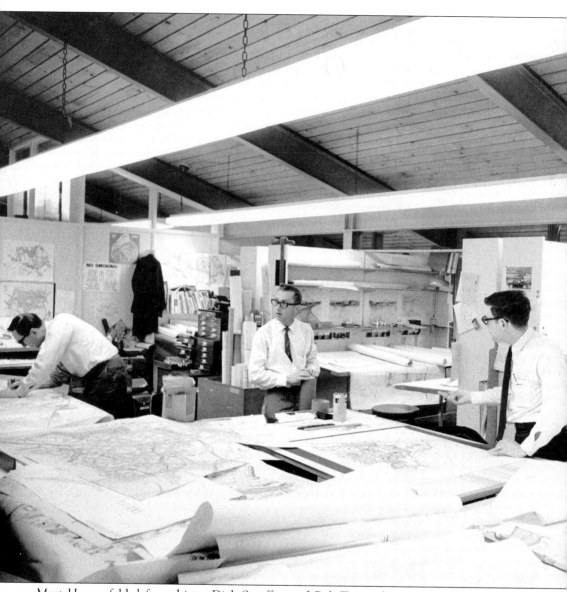

Mort Hoppenfeld, left, architect Dick Stauffer, and Bob Tennenbaum worked closely in the Columbia Planning and Design office located in the Rouse Company headquarters in Cross Keys in Baltimore. (Photo by Rodney Boyce.)

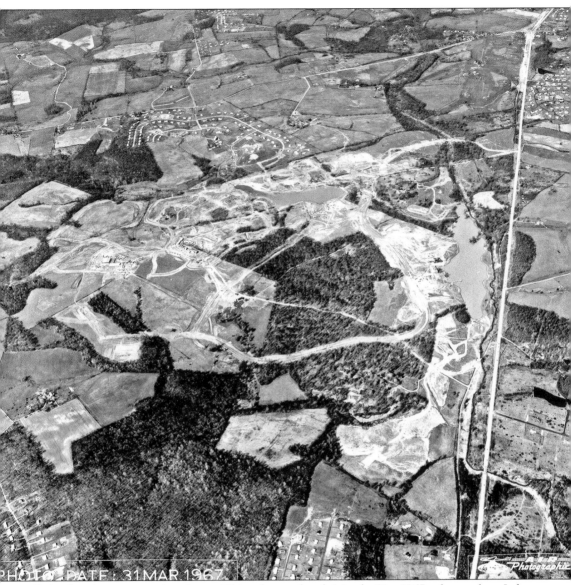

PHOTO DATE: 31 MAR 1967.

Columbia begins to take shape. This photo, dated March 31, 1967, shows that Lake Kittamaqundi and Wilde Lake have been dug and are filled. The first roads have been carved out and work has begun on the first office buildings in Town Center, the Wilde Lake Village Center, and the first apartment complex. (Photo by Air Photographics.)

19

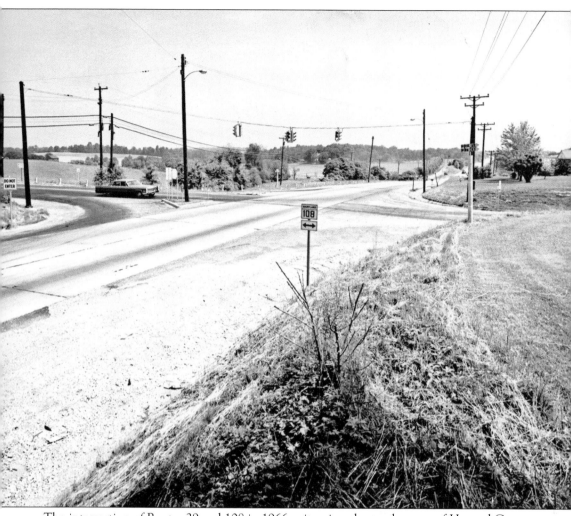

The intersection of Routes 29 and 108 in 1966 epitomizes the rural nature of Howard County. However, plans were already underway at the time for the widening of Route 29 north of Columbia, and HRD negotiated with State Roads Commission to continue that improvement through Columbia. (Photo by Rodney Boyce.)

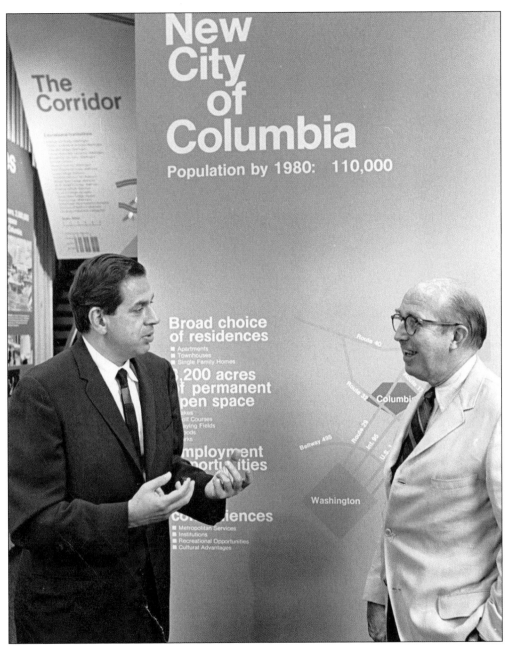

The marketing of Columbia is a story in itself. One of the tools was an exhibit in Washington, D.C. James Rouse, right, shows it off to Charles Harr, assistant secretary for metropolitan development in the United States Department of Housing and Urban Development.

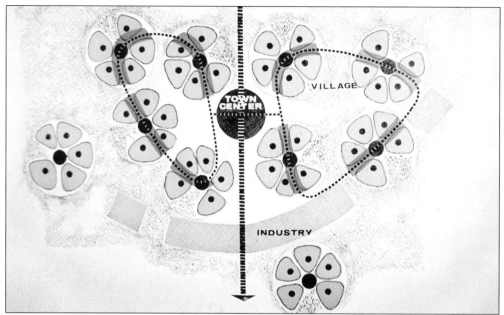

Rouse's initial, unscientific conclusion that people grow best in small towns was echoed by the work group deliberations about optimal size of communities. This led to the basic layout of villages surrounding a town center and the division of each village into neighborhoods. The neighborhoods, which have populations of between 3,000 and 5,000, were designed as the building blocks of community.

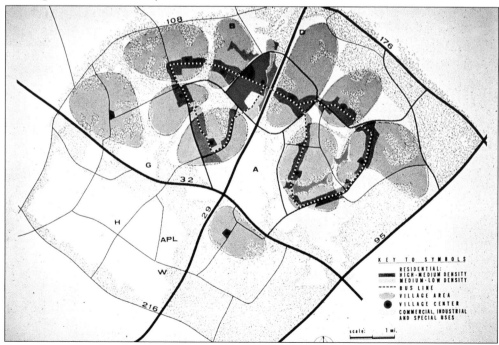

As work progressed and the characteristics of the land were factored in, a more realistic sketch of the location of villages, land uses, and infrastructure was drawn. The dotted line represents the bus route designed to serve the village centers, apartments, townhouses, and Town Center.

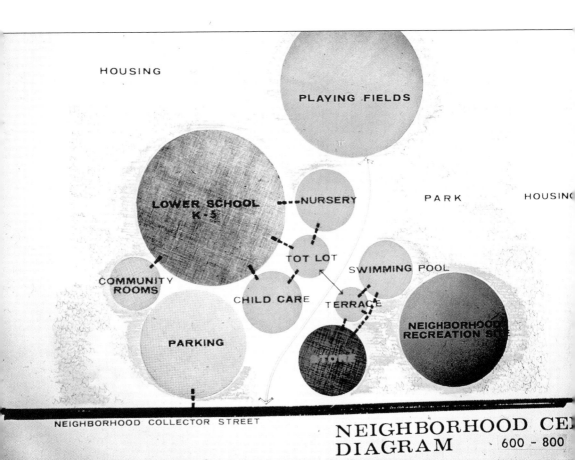

HOUSING

PLAYING FIELDS

LOWER SCHOOL
K-5

NURSERY

PARK

HOUSING

TOT LOT

COMMUNITY
ROOMS

SWIMMING POOL

CHILD CARE

TERRACE

NEIGHBORHOOD
RECREATION SITE

PARKING

STORE

NEIGHBORHOOD COLLECTOR STREET

NEIGHBORHOOD CE
DIAGRAM 600 - 800

The elementary school, playground, neighborhood store, swimming pool, and nursery or child care center were the key elements of the neighborhood center design. The stated purpose was to cluster activities for the family and provide a safe place particularly for small children.

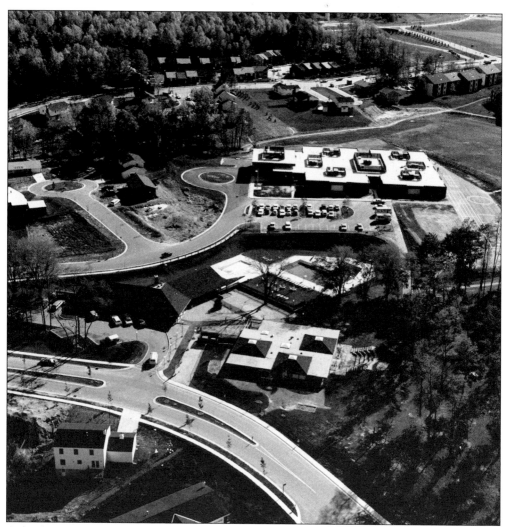

Columbia's first neighborhood center, Bryant Woods, had all the elements included in the plans: an elementary school, the swimming pool, and the community center adjacent to the main street of the neighborhood. (Photo by Morton Tadder.)

Sketches used in early presentations graphically illustrated that a town center was one of the most important elements that would distinguish Columbia from other suburban development. People moving to Columbia would not have to drive to a city to shop, work, or play. Town Center would bustle with pedestrian traffic and yet offer a balance with nature with its man-made lake.

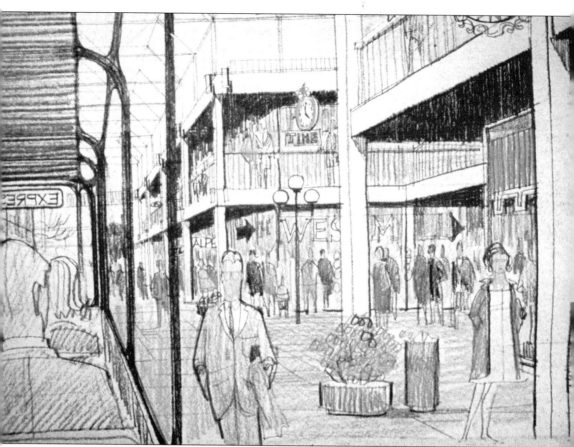

An artist's rendering of Town Center that first appeared in the binder distributed at the presentation to the officials and citizens of Howard County on November 11, 1964, included the idea that buses would actually drive into the mall.

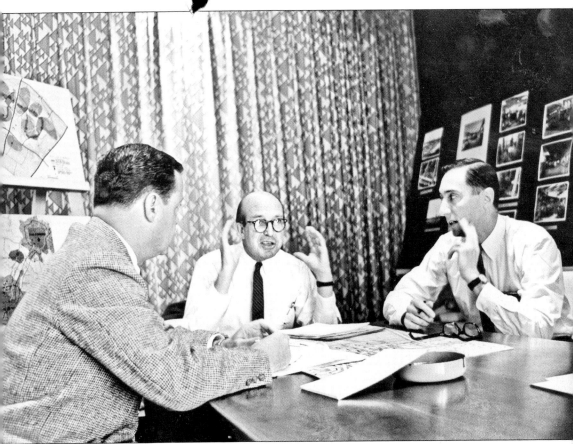

Columbia's key players were, from left to right, Bill Finley, James Rouse, and Mort Hoppenfeld. "It was up to us to prove that we could plan a city that would constitute a better alternative to sprawl," said Rouse. (Photo by Robert de Gast.)

The sign says, "Columbia—Field Office and Temporary Exhibit." It was a small house near Route 29 that became known as the Smith House. Maps and sketches hung on the wall and the three-dimensional model of Town Center formed the cornerstone of the exhibit. The interest it generated led to the decision to build an Exhibit Center in Town Center that would tell and sell the story of Columbia for more than 20 years.

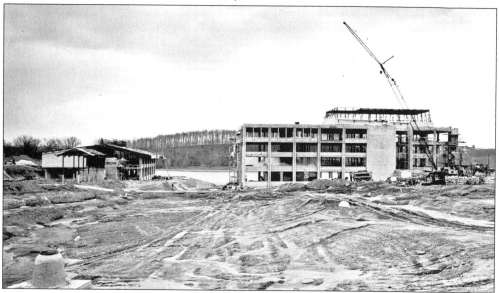

The permanent Exhibit Center, left, was strategically sited on the shore of Lake Kittamaqundi next to Columbia's first office building. This April 3, 1967 photograph hints at the frenetic pace of construction as Columbia's public debut drew near. This building would open in a little more than two months, on the day of Columbia's beginning, June 21, 1967.

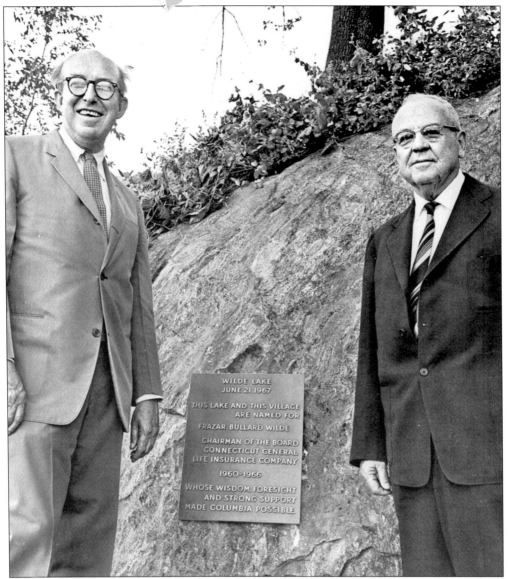

James Rouse, left, and Frazar Wilde flank the plaque that was installed for the dedication of Wilde Lake. During the ceremony, Rouse praised Wilde, calling him "one special, indispensable hero," for responding to an "outrageous proposal" and partnering in the Columbia project by providing the necessary financing.

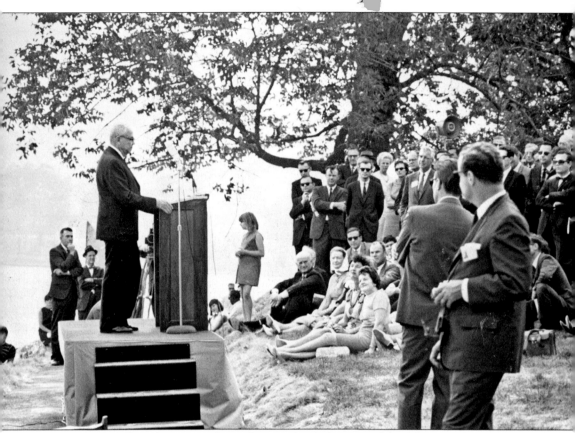

Frazar Wilde followed Rouse at the podium at the dedication of the lake named in his honor. After listening to Rouse credit him for making Columbia possible, he said of Rouse, "no matter what back-up he had"—referring to the generous financial investment by the Connecticut General Insurance Company—"there would be no Columbia unless somebody had the imagination and the leadership to start such a project."

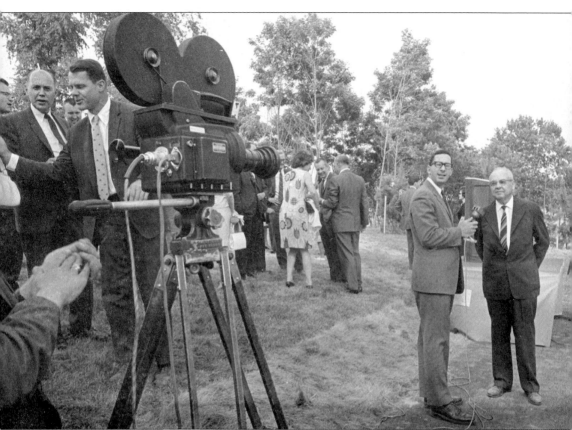

Frazar Wilde is interviewed after the ceremonies marking the dedication of Wilde Lake. He told the audience that the project was of interest to the Connecticut General Insurance Company because Rouse and his team "had an idea of combining commercial success in the building and development field with a sense of the aesthetic, a sense of gracious living." (Photo by George de Vincent.)

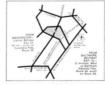
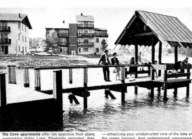

There was the vision, the land acquisition, the planning, and the building. Columbia was ready for visitors and residents. Full page ads such as this one began running in Baltimore and Washington newspapers, and people came.

Two

RESPECTING THE LAND
AND THE PAST

I believe there should be a strong infusion of nature . . . that people should be able to feel the spaces of nature—all as a part of his everyday life.

—James Rouse

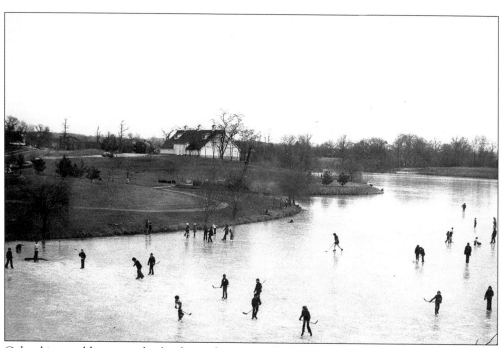

Columbia would respect the land—in fact, it would ennoble the land. With the creation of Wilde Lake came a picture-perfect spot for enjoying the winter. In recent years, there have not been many winters when the lakes froze solid enough for safe skating.

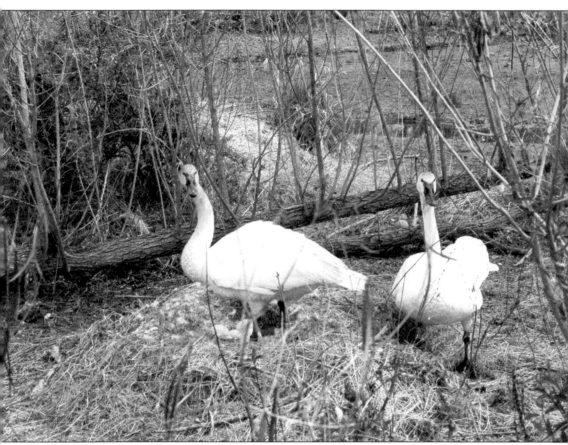

The commitment to open spaces and protecting natural habitats has created an urban wildlife refuge. Trumpling swans, a hybrid of Trumpeters and Whistlings, nest near Lake Elkhorn. Herons, hawks, and other waterfowl make Columbia a permanent or temporary home during migration.

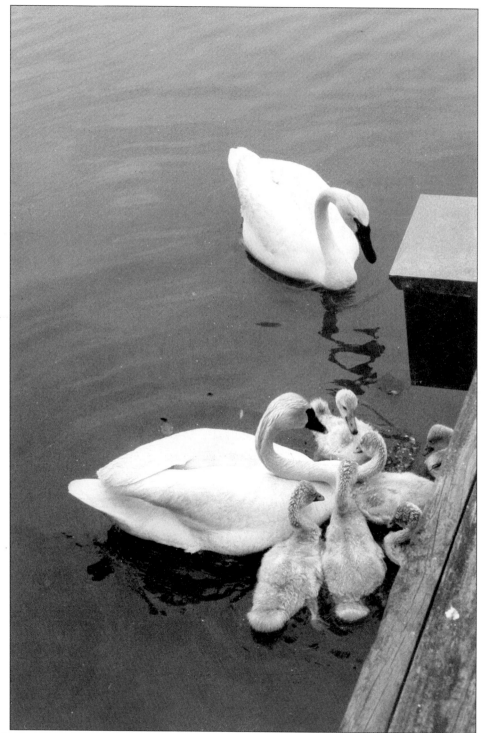

Captive native hybrid swans have resided on Columbia's lakes for many years through a program with Environmental Enterprises located in Airlie, Virginia. One pair that was in residence on Wilde Lake for many years was dubbed Jim and Patty, after the Rouses.

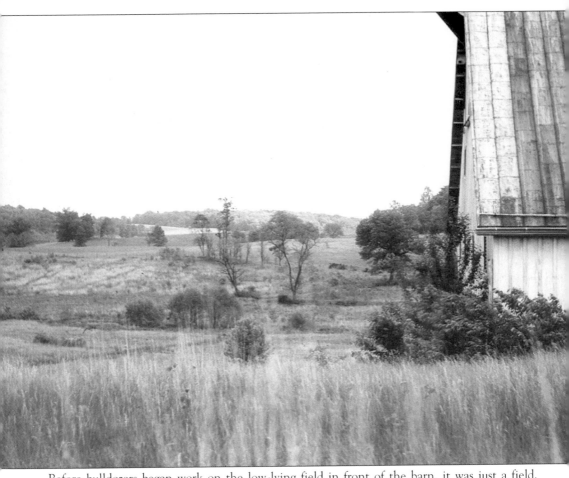

Before bulldozers began work on the low-lying field in front of the barn, it was just a field. Shortly after this picture was taken, work began on the construction of Wilde Lake.

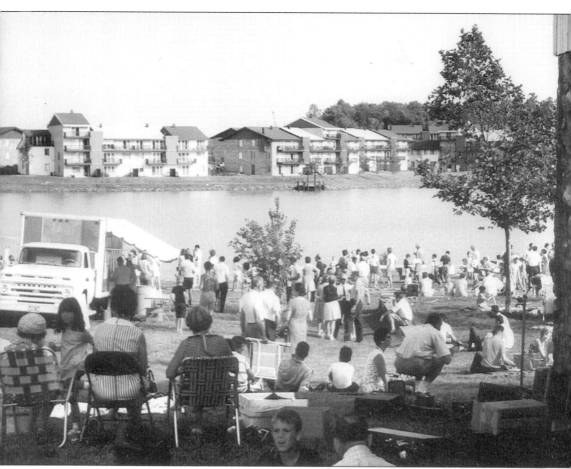

"We can't plan effectively for the future growth of American communities unless we start at the beginning and that beginning is people," said Rouse in 1963. A year after Wilde Lake was dedicated, people flock to the shores. The barn is now a part of a place for people.

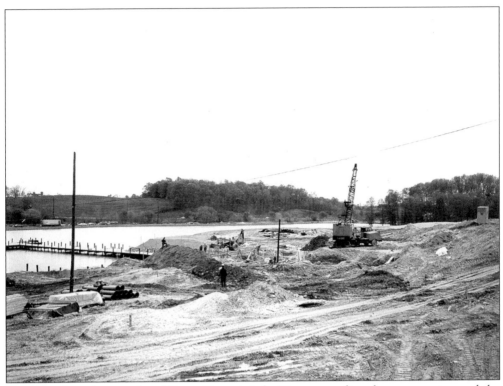

Corresponding photographs of Town Center's Lake Kittamaqundi under construction and the finished product illustrate the goal to respect the land by preserving trees and contours. (Photo by Max Araujo.)

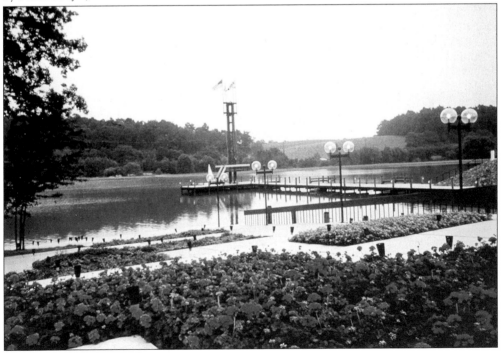

One of the two islands in Town Center's Lake Kittamaqundi was created to try to preserve four pin oak trees. The trees did not survive, but the larger island was the subject of a naming contest and is known as Nomanisan Island.

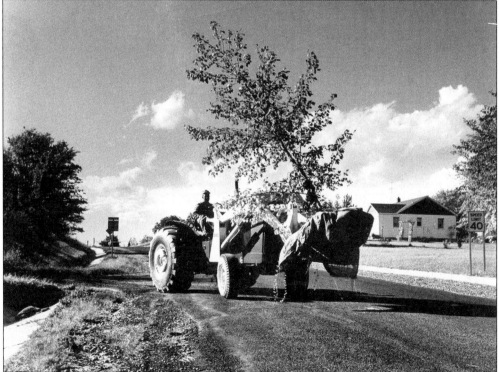

A tree transplanter was used to salvage trees wherever possible when land was cleared. Uprooted trees were relocated to temporary storage rows until projects were ready for final landscaping.

The land management crew, led by John Shallcross (left), got involved in a wide variety of operations. A nursery manager and a general farming manager were but two of the positions needed to supervise the thousands of acres set aside for a timber improvement program, to manage the farms, nurseries, and pastureland, and to oversee the land leased to farmers.

A swath of land is being cleared in 1970 to make way for the mall. But Symphony Woods, a 40-acre, densely treed park in the middle of Town Center, is designated permanent open space, part of Columbia's commitment to preserve the land. Merriweather Post Pavilion—the open air concert venue designed by Frank Gehry—stands out amid the surrounding woods. (Photo by Morton Tadder.)

The first presentation of the plan for Columbia said, "Town Center will capture all the vitality and excitement of urban life in a setting of natural beauty." It promised an enclosed mall,

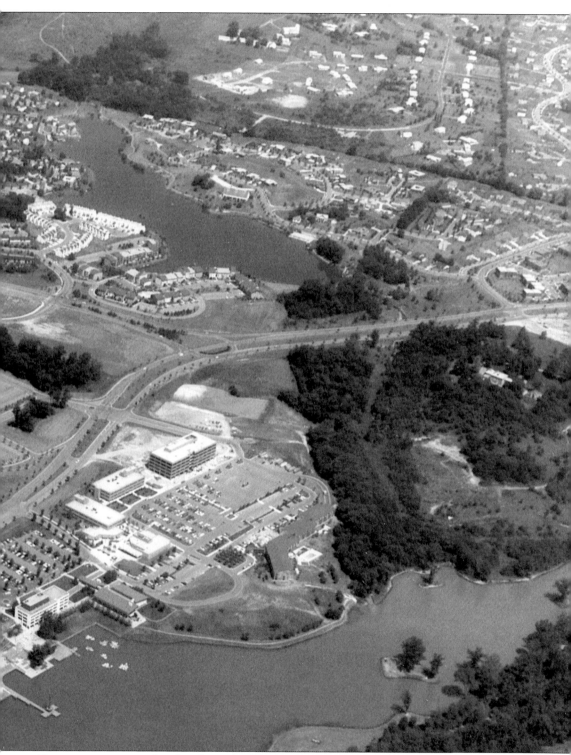

offices, restaurants, and cafés along the lake, a dock for small boats, and townhouses and apartments. In 1971, the first pieces were in place.

Of the more than 140 parcels purchased during the initial land acquisition for Columbia, none had the number of significant historic structures that were on this property, purchased from Miriam Keller. The buildings date to the 1800s and were part of Oakland Manor. The land in the forefront was excavated, and Wilde Lake was formed. The buildings were preserved, giving the new town of Columbia deeper historical roots and architectural character.

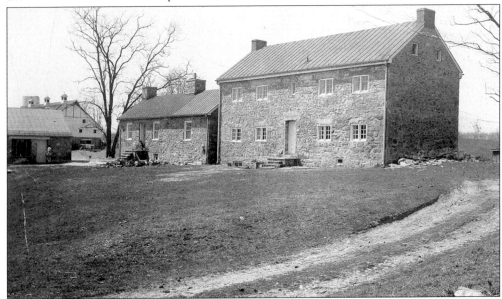

In 1952, the buildings on the Keller property had a decidedly different look. The two-story house retained more of the early 19th-century appearance it had when it served presumably as the tenant house for Oakland Manor.

By 1955, Keller had added a façade and "modern" door that dramatically changed the look. That was only the beginning of the changes that would eventually be made.

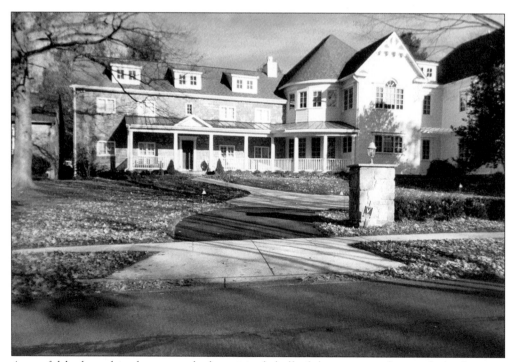

A careful look at this photo reveals the original shell of the two-story house after a dramatic renovation was completed in 2004. The house had been in the Ralston family until 2002 and had changed little from the 1950s, when Miriam Keller owned it. Keller had sold the house to Ralston several years before she sold the rest of her property to Rouse.

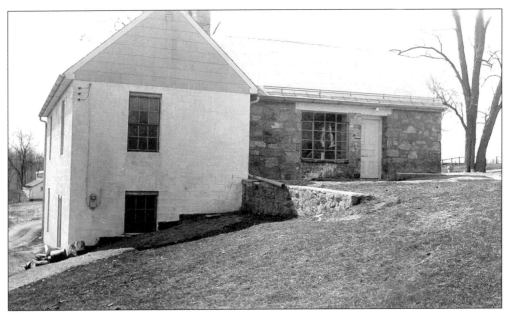

This building, believed to have been a blacksmith shop for Oakland Manor, had been enlarged and used as a residence in the 1950s. Under HRD ownership, it was used for a short time as Columbia's first post office.

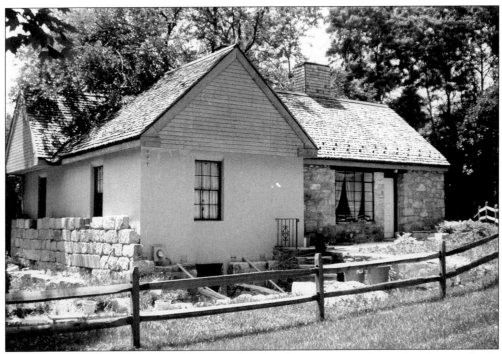

In the mid-1980s, it was purchased by Bruno Reich, who spent more than a decade completely renovating it and changing its character. The HGTV cable channel became intrigued by the story of Reich's project and produced an 11-episode feature following his progress over several years.

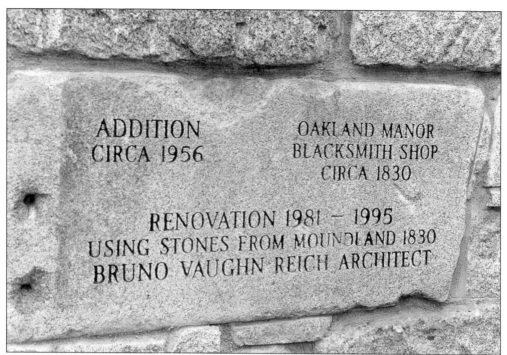

ADDITION
CIRCA 1956

OAKLAND MANOR
BLACKSMITH SHOP
CIRCA 1830

RENOVATION 1981 – 1995
USING STONES FROM MOUNDLAND 1830
BRUNO VAUGHN REICH ARCHITECT

Reich highlighted the history of the house in stone.

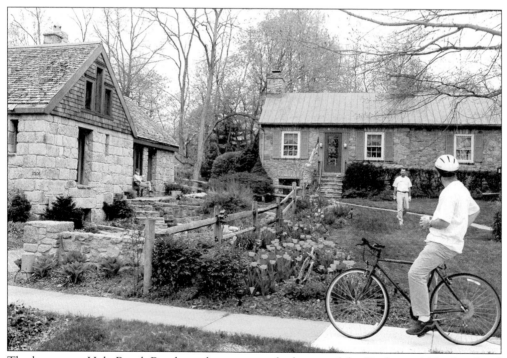

The houses on Hyla Brook Road stand out among the homes of the Birches neighborhood and are a popular stop on historic tours.

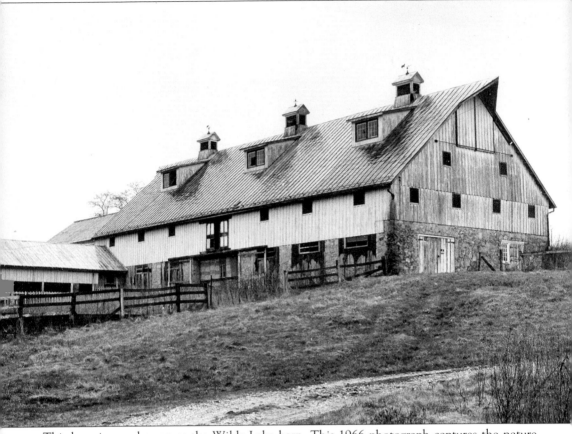

This barn is now known as the Wilde Lake barn. This 1966 photograph captures the nature of Howard County immediately preceding the development of Columbia. With a little imagination, one can see the cows and the hay. Shortly after this photograph was taken, several sheds were removed during the restoration project.

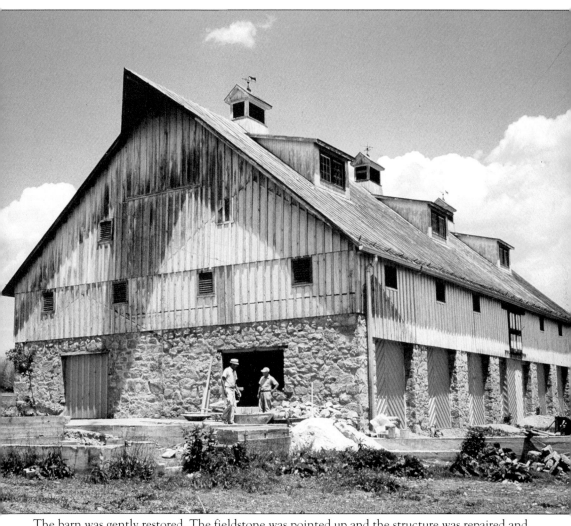

The barn was gently restored. The fieldstone was pointed up and the structure was repaired and painted. The roof was painted red, and the large barn with historic ties began its new life as a highly visible landmark.

DESIGNATED A
HISTORIC LANDMARK
OF
AGRICULTURAL ENGINEERING

AT OAKLAND MANOR IN 1876
FRANCIS MORRIS
BUILT BRICK SILOS IN HIS BARN AND
INTRODUCED THE PRACTICE OF MAKING
CORN SILAGE IN THE UNITED STATES.
HIS FURTHER EXPERIMENTS DEVELOPED THE USE
OF EARTHEN TRENCHES AND THEREBY
SIGNIFICANTLY CONTRIBUTED TO THE
DEVELOPMENT OF AMERICAN AGRICULTURE.

DEDICATED BY
AMERICAN SOCIETY OF AGRICULTURAL ENGINEERS
1976

Francis Morris, a prominent agriculturist, purchased Oakland Manor in 1874. This plaque affixed to the side of the barn in Wilde Lake attests to his achievements and the history of this old place in a new town.

The animal shed from the Keller property was preserved, restored, and incorporated into the dock area of Wilde Lake Park. The building is used by Columbia Association's Nature Camp during summer months. (Photo by Morton Tadder.)

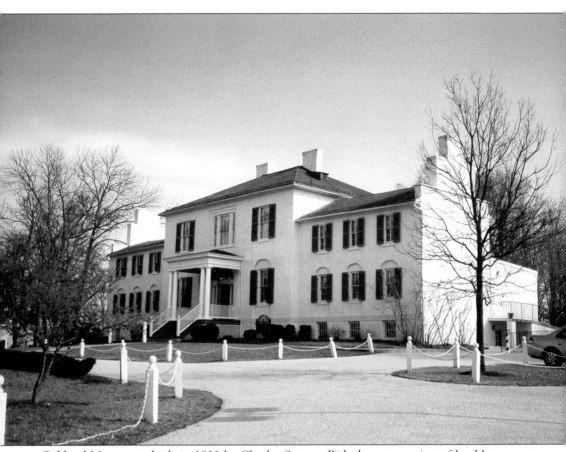

Oakland Manor was built in 1811 by Charles Sterrett Ridgely on a portion of land known as Felicity. Over the next 150 years, the names Oliver, Gaither, Tabb, Morris, Price, and Keller were connected to the property. In the 1960s, most of the property was owned by Miriam Keller and was purchased as a key piece in the Columbia land puzzle. Oakland Manor has served as field offices for HRD, an Antioch College campus, Dag Hammarskjold College, and offices for the American Red Cross. Since 1989, Columbia Association has owned and restored it, and it is a significant community resource. (Photo by Natalie Harvey.)

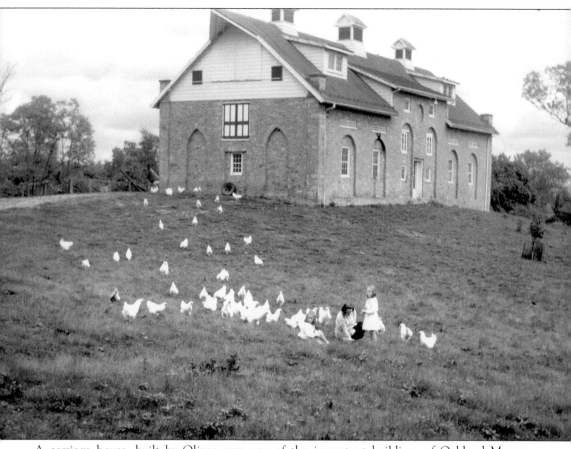

A carriage house, built by Oliver, was one of the important buildings of Oakland Manor. This photograph was taken in 1953, when Miriam Keller owned the property. She referred to it as the "front barn" to distinguish it from the barn that Columbians now refer to as the Wilde Lake Barn.

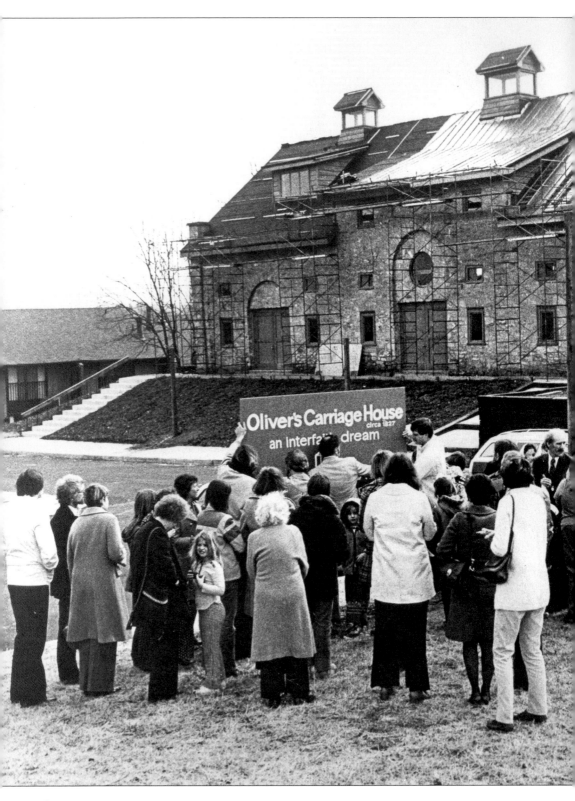

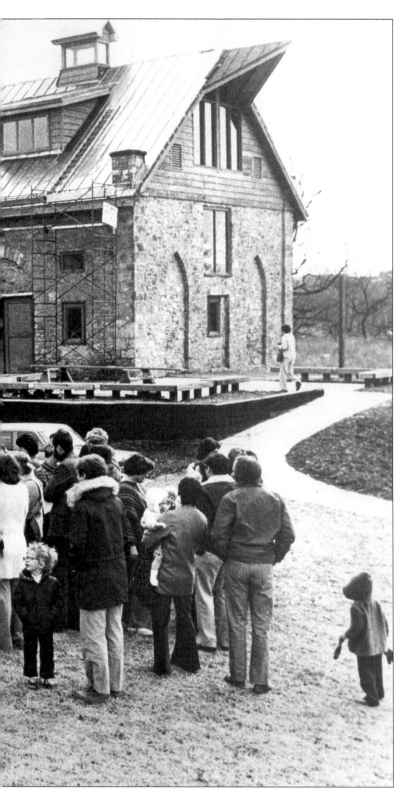

Oliver's Carriage House was dedicated as the permanent home of the Kittamaqundi Community in 1977. Much of the character of the barn was preserved in the renovation. First-floor offices were created out of the stable walls and incorporate the original gates. This non-denominational Christian church was started by James Rouse and his first wife, Libby, and John and Dede Levering, among others.

The tot lot on Rain Dream Hill in Wilde Lake is a hidden historic treat for area youngsters. The play area utilizes the remains of Bleak House. Howard County legend tells the tale of Rebecca Gaither hiding out in this house during the Civil War when Union troops ransacked Oakland. At the time, her husband, Col. George Gaither, was in Europe rallying support for the Confederate cause. (Photo by Ron Fedorczak.)

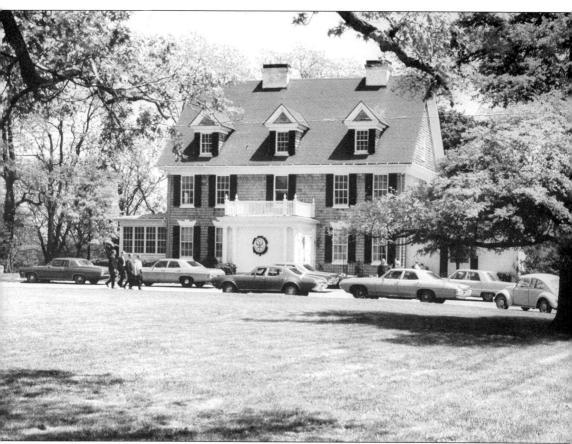

The early 20th-century home built by the Macgill family was converted into a restaurant and named Kings Contrivance in 1962 by Kingdon Gould. The Rouse Company acquired the restaurant from Gould, along with much of the surrounding land. It is still a restaurant—one of Columbia's finer eating spots. The neighborhood of Macgill's Common in the village of Kings Contrivance has grown up around it.

Donald and Ethel Sewell grew apples, peaches, blackberries, strawberries, and other fruit on a 200-acre farm they acquired in 1943. In 1963, they sold 29 acres to HRD to allow for the sewer easement. The rest of the property remained in the family, which continued the operation even after Donald's death in 1971. However, by the early 1980s, the farm had been divided and sold for development.

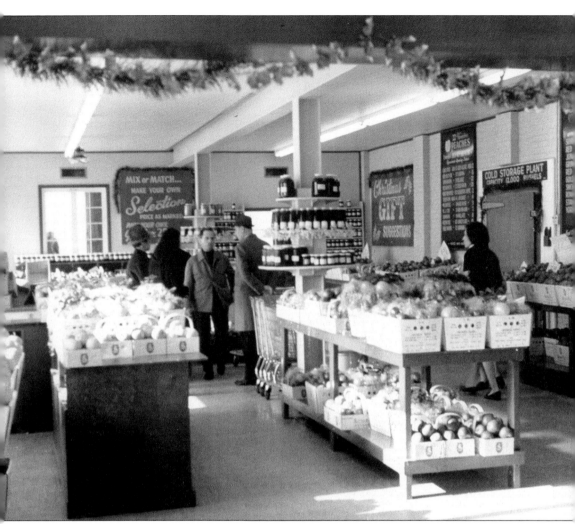

Until it closed in 1983, the Sewell's Orchards store was a popular place for "citified" Columbians to buy fresh-picked fruit. The only vestiges of the orchard since the land was sold for residential development are some fruit trees in the yards of the houses and in the names of streets such as Grimes Golden, Early Red, and Autumn Gold.

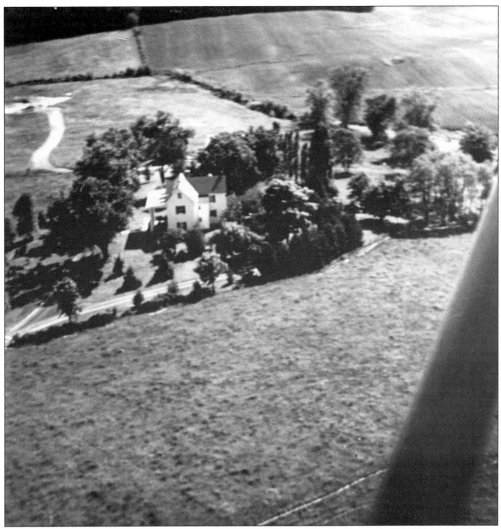

Irvin Dasher and his wife Grace lived in this house; brother George Dasher and his wife Marie lived not far across the fields. Together, they eked out a living and raised their children on a 600-acre dairy farm. The brothers sold their property to Rouse in 1963 but kept small homesteads on which they lived and farmed for many years in the neighborhood of Dasher Green.

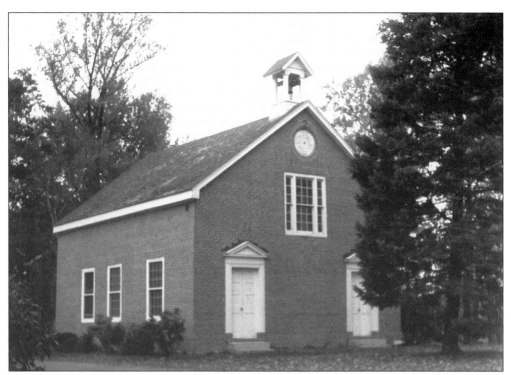

Christ Episcopal Church is clearly historic *and* progressive. The "Old Brick," as it has always been called, was built in 1809. The congregation is even older than that, tracing its roots to a chapel of ease erected on the spot in 1711. In 1730, James Macgill arrived to serve as the first rector. But even with its history, Christ Church was a supporter of Columbia's interfaith concept and a founding member of the Columbia Cooperative Ministry.

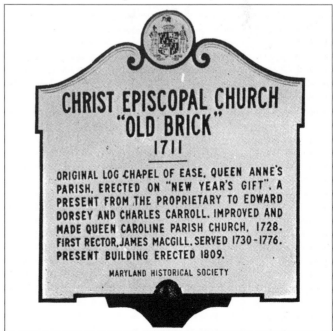

CHRIST EPISCOPAL CHURCH
"OLD BRICK"
1711

ORIGINAL LOG CHAPEL OF EASE, QUEEN ANNE'S PARISH, ERECTED ON "NEW YEAR'S GIFT". A PRESENT FROM THE PROPRIETARY TO EDWARD DORSEY AND CHARLES CARROLL. IMPROVED AND MADE QUEEN CAROLINE PARISH CHURCH, 1728. FIRST RECTOR, JAMES MACGILL, SERVED 1730-1776. PRESENT BUILDING ERECTED 1809.

MARYLAND HISTORICAL SOCIETY

This Maryland Historical Society marker on Oakland Mills sheds light on the history of Christ Church.

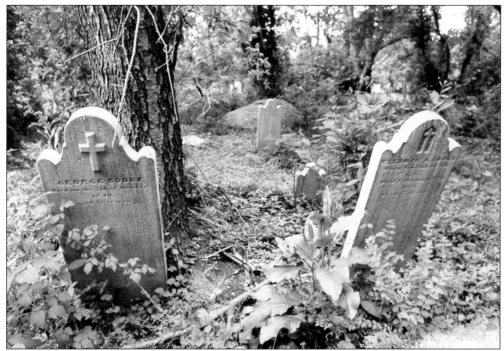

The remains of George Cooke and his family lie obscured in a family graveyard now surrounded by townhouses and the Oakland Mills Village Center. A diary that Cooke kept from 1826 to 1849 offers valuable insight into farm life in Howard County. The original diary is at the National Agricultural Library in Beltsville, Maryland.

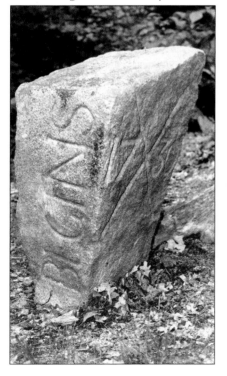

The Athol Marker sits in preserved open space in the Clemens Crossing neighborhood of Hickory Ridge and links Columbia to a long-ago past. Chiseled into the stone is "Athol Begins Here 1730." It marks the original land grant of Rev. James Macgill, who patented the land and named it for his ancestral home in Scotland. Macgill served as rector of Queen Caroline Parish Church, which became the Christ Episcopal Church on Oakland Mills Road in Columbia.

Three
CREATING A COMPLETE CITY

Without vision, there is no power.

—James Rouse

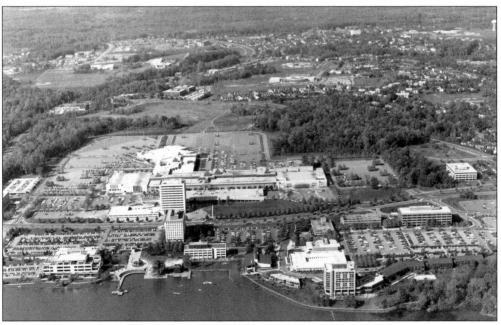

The goal was a real city. If we define city as a place that provides for its residents' needs, we can measure Columbia's success by the wide variety of housing, employment, and shopping opportunities and the extensive cultural, recreational, educational, religious, and medical facilities that are provided. Much of what makes Columbia a special place is intangible, but there are buildings, places, and events that tell part of the story.

In 1968, Columbia hardly qualified as a "city." But a three-part CBS investigative series on cities featured Columbia on the final segment, which focused on building the future. CBS commentator Walter Cronkite and his crew set up for filming in Wilde Lake Village Center during one of the visits to Columbia to interview Rouse and others and to film the new city from the ground and from the air.

The first promise of a shopping center was a welcome sign for residents. Village Centers, with their supermarkets, restaurants, and small stores, supplied basic needs, but Columbians had to venture to Route 40 near Baltimore or to Silver Spring for department stores.

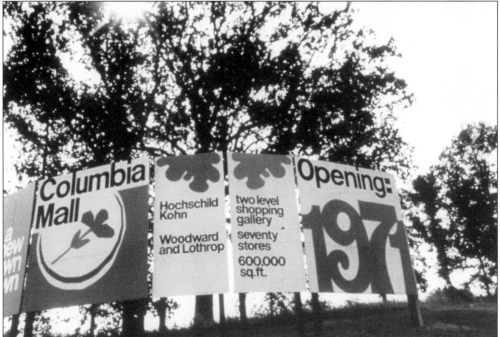

Once Woodward & Lothrop, a Washington-based retailer, committed to anchor the mall, a more formal sign was put in place. The mall was a crucial part of the Town Center design. Rouse was pioneering the development of shopping malls, and this was to be more than just a place to shop. It was to be a community space—Columbia's "Main Street."

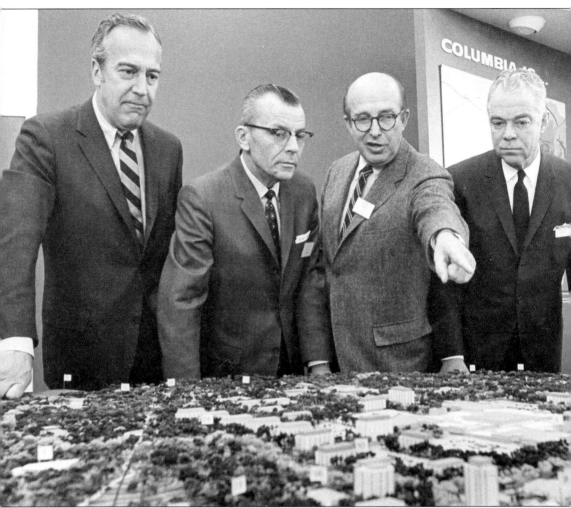

Woodward & Lothrop, a Washington-based retailer, signed on as an anchor for the mall in February 1969. Hochschild Kohn had signed on more than a year earlier. This marked the first time that a Baltimore store and a Washington store would occupy the same mall. Rouse points out the location to (from left to right) Edwin Hoffman, W&L executive vice president; Omar Jones, Howard County executive; and Andrew Parker, W&L president.

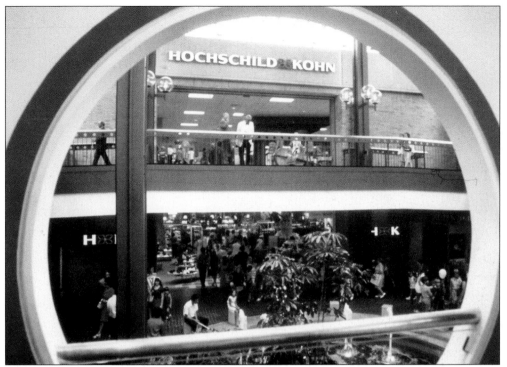

Hochschild Kohn, a Baltimore-based department store, was the first tenant to sign for the Columbia mall. When it closed in 1975, the space was taken over by the Hecht Company.

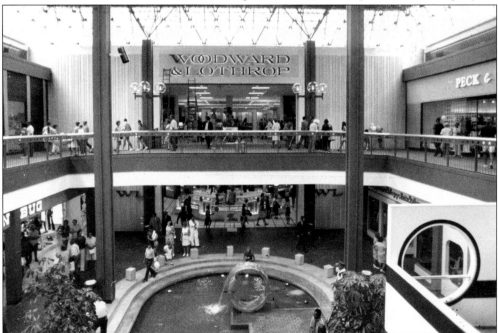

"Woodies," as the Washington-based Woodward & Lothrop was commonly referred to, promised "the store of tomorrow" in its initial announcement. It anchored the mall until 1995. Its Patuxent Room restaurant was a favorite.

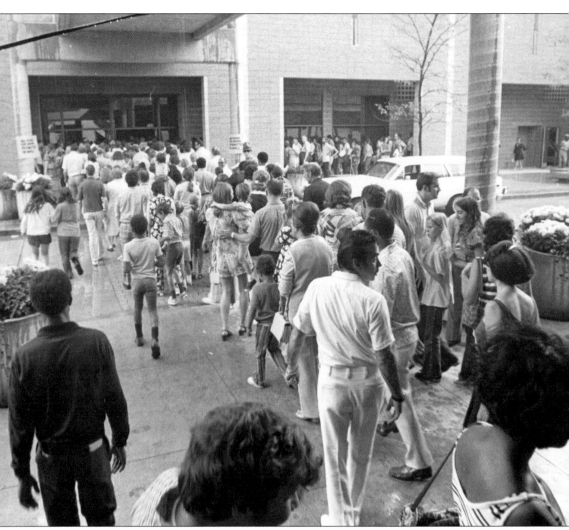

A sneak preview of the Mall in Columbia on Sunday, August 1, 1971, drew thousands of Howard Countians for an old-fashioned bull roast in the parking deck and a chance to explore the new shopping center in a "community" way—by browsing. Stores were not open on Sundays. The mall officially opened on Monday, August 2. (Photo by Jerry Wachter.)

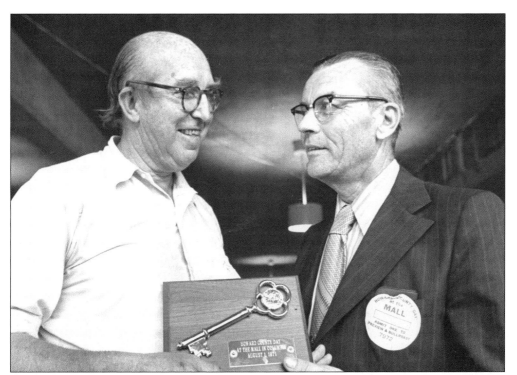

Howard County executive Omar Jones presents Rouse with the official commemorative of Howard County Day at the mall. (Photo by Jerry Wachter.)

The mall opened on August 2, 1971, with 80 of the 102 specialty shops and the two anchors. Father John Walsh delivered the invocation at the official opening: "We give praise for the creativity of those who design new shapes and forms; for those who today dream dreams and see visions of what might be tomorrow; for those who answer the doubtful 'why?' with the affirmative 'why not?'"

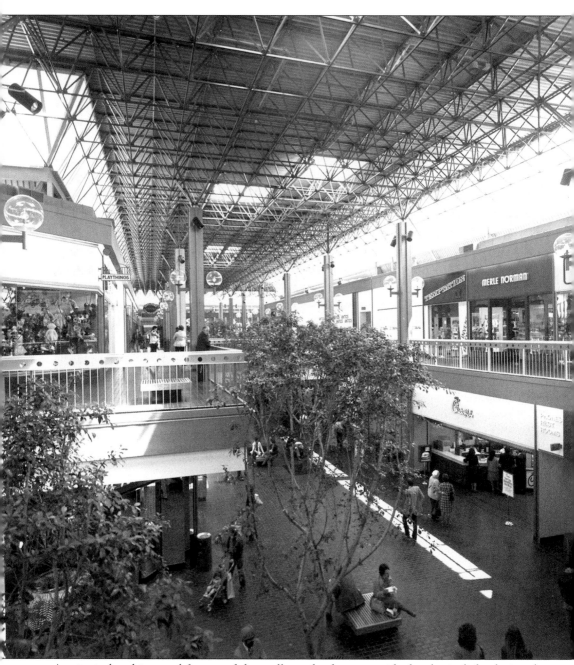

A principal architectural feature of the mall are the four pyramids that let in light during the day to create an outdoor atmosphere and reflect light at night, making them highly visible from afar. The whole design, from the brick paving to the New England street clock, was intended to give the feel of an outdoor marketplace.

In 1981, the Florence Bain Senior Center opened in Harper's Choice. It was named for a woman who was 15 years into retirement and a widow with no history of activism when she moved to the new town of Columbia in 1967. Most of Columbia's residents were young, and there were not many services for her age group. At age 70, she became an advocate for senior citizens, chaired the Commission on Aging, founded the local chapter of AARP, and convinced Jim Rouse to reserve space for the community's first senior center.

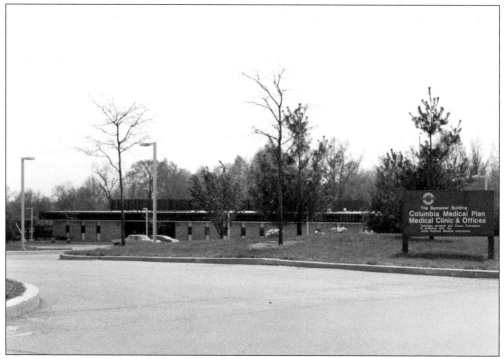

One of the innovative ideas that resulted from the planning process was the Columbia Medical Plan, a health maintenance organization developed by Johns Hopkins Medical Institutions and underwritten by Connecticut General Insurance Company. The first office was in the Banneker building on Banneker Road.

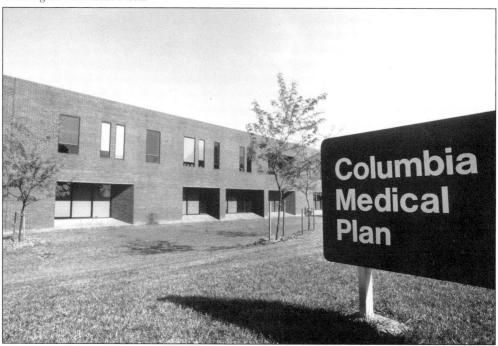

Columbia Medical Plan moved to offices on Harpers Farm Road in the mid-1970s.

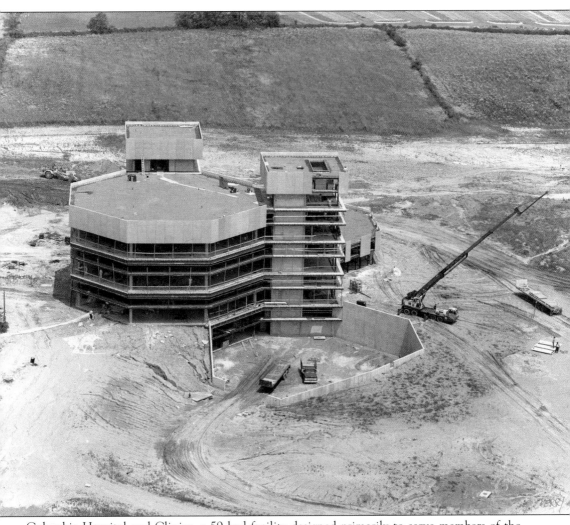

Columbia Hospital and Clinics, a 59-bed facility designed primarily to serve members of the Columbia Medical Plan, opened in 1973. Even before it was ready to open, there was talk of an expanded mission.

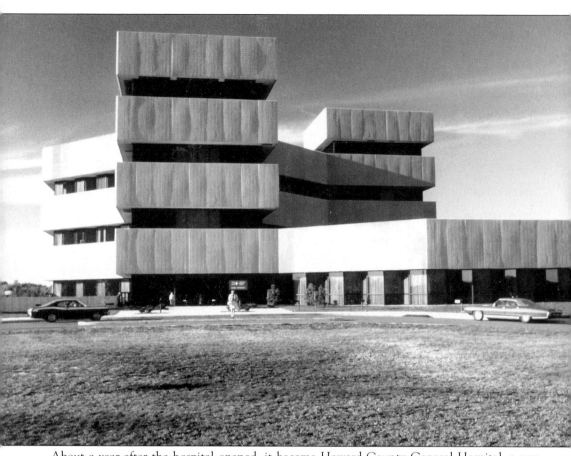

About a year after the hospital opened, it became Howard County General Hospital, a non-profit, citizen-owned facility serving the entire area and not limited to members of the Columbia Medical Plan.

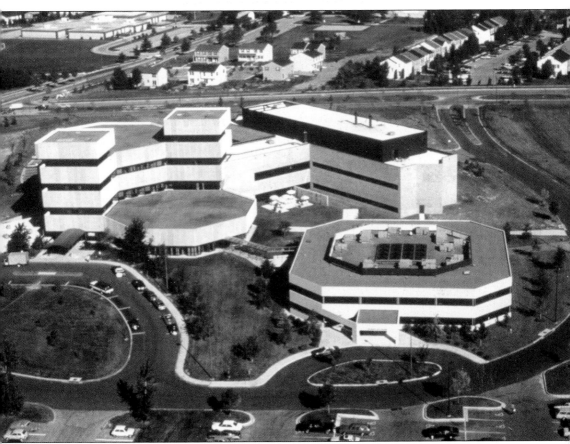

The unique eight-sided architectural pattern of the hospital was designed to allow for expansion, and it has grown through the years to meet the needs of Howard County's increasing population. This photo shows growth through the mid–1980s. In 1998, it became part of Johns Hopkins Medicine, further expanding its services to the county.

The fountain in Town Center was designed by Columbia's chief planner, Mort Hoppenfeld. He was inspired by the classical fountains he saw in Tivoli Gardens near Rome. Hoppenfield very much wanted Town Center to be a place where people would congregate and enjoy the natural beauty of the lake and a variety of entertainment.

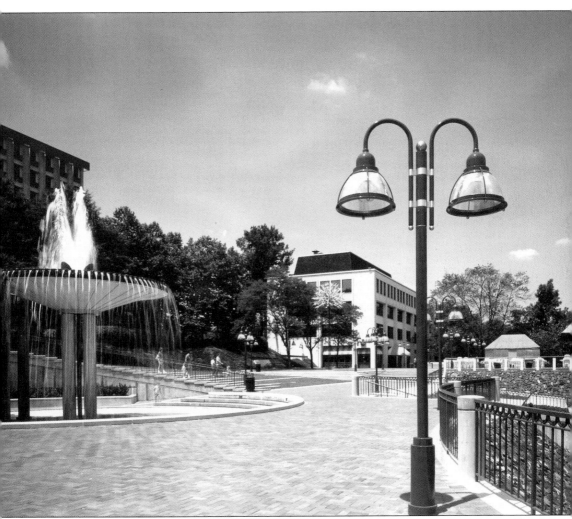

It doesn't look it in this photograph, but Town Center does bustle with activity, especially during special events and warm sunny days when the fountain beckons people to walk under the waterfall. When that happens, Town Center is working as it was intended.

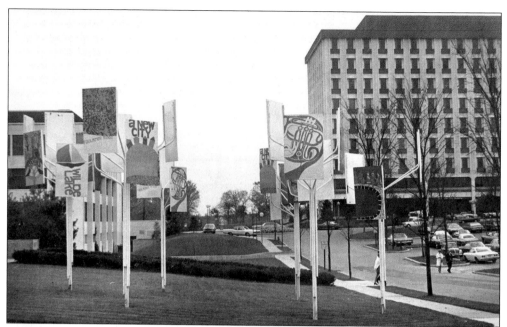

Bright, strong, graphic posters "planted" like trees in front of the Exhibit Center proclaimed a new city and the promise of a vibrant, creative place to live. The posters were the work of Gail Holliday, a young student of noted graphic artist Sister Mary Corita, hired by Rouse and given the freedom to create. (Photo by Fern Eisner.)

Gail Holliday produced posters for neighborhoods and villages, giving special identification to these places. She, along with another Rouse-retained artist, Pierre du Fayet, brought public art to Columbia in its earliest days.

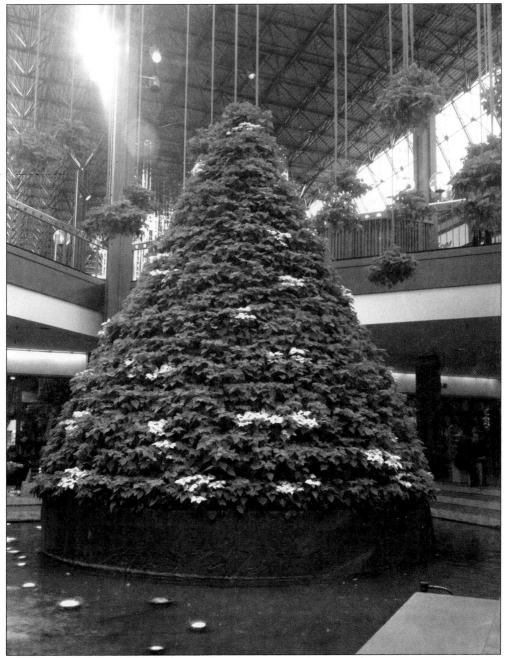

In 1972, when the year-old mall was looking for something a little different for its holiday season decorations, the Poinsettia Tree took root. Leroy Brown, a landscape manager for The Rouse Company, conceived the idea, drew up the plans for a circular, ten-tiered frame, and was the first to climb to the top of the structure to put the poinsettias in place. It took three days to put together the framework, install the watering system, and assemble the 600 plants on the 27-foot high structure. The Poinsettia Tree is a Columbia tradition and landmark.

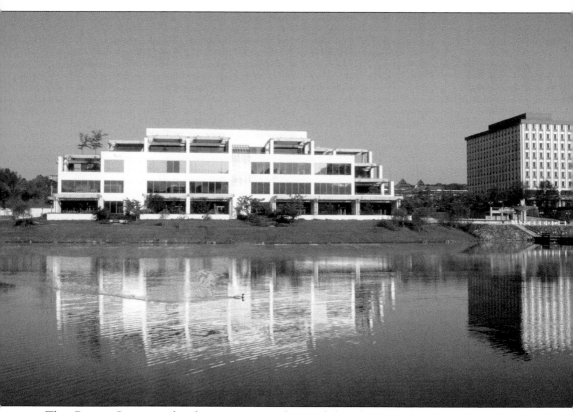

The Rouse Company headquarters were designed by the now-famous architect Frank Gehry. Certainly Columbia's most dramatic building, it is perched on the shore of Lake Kittamaqundi and often casts a rippling shadow that foreshadows Gehry's signature undulating, sculptural work.

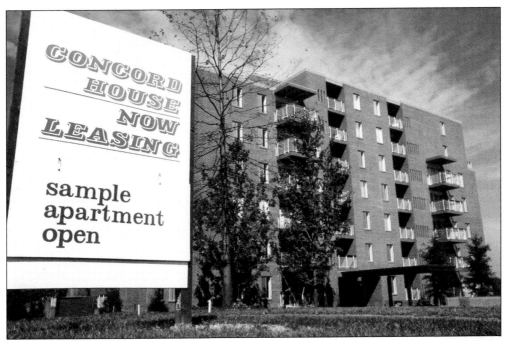

Concord House was Columbia's first mid-rise apartment building. No builder wanted to take the chance on this type of building, but it was very important to the plan to provide a variety of housing options, so it fell to the Rouse Company to build it. It proved to be very successful, exploding the myth that there was no market for this "city" look in the "country."

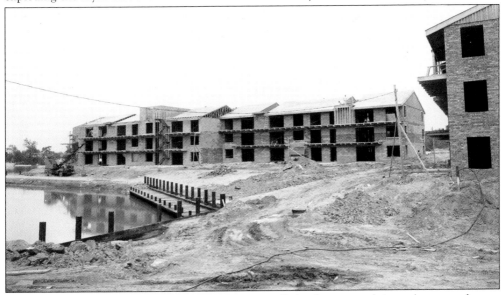

The Cove—among the first apartments to open in Columbia—can claim at least one famous resident. Oprah Winfrey lived there in the late 1970s when she hosted the television show *People are Talking* in Baltimore. The Rouse Company used one of the three-story units as a guest house for its visitors and for artists who were performing at Merriweather Post Pavilion from 1968 to 1972. One early visitor wrote in the guest book, "Just a bit closer to heaven than most." (Photo by Max Araujo.)

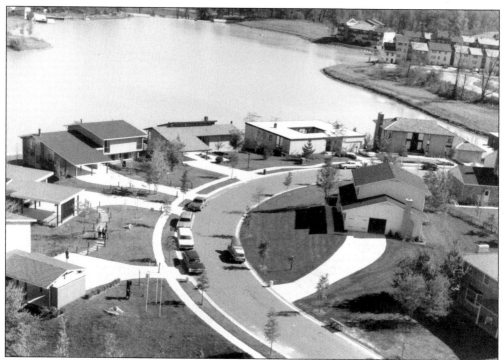

"We wanted the janitor and the company executive to live in the same neighborhood," Rouse often said. Apartments, townhouses, and single-family houses were built within blocks of each other. In the Bryant Woods neighborhood, Waterfowl Terrace, with its waterfront lots, was set aside for custom-designed homes. Among the residents on that street have been Rouse and his wife Patty, as well Pat Kennedy, who served as president of Columbia Association from 1972 to 1996, and his wife, Ellen. (Photo by Morton Tadder.)

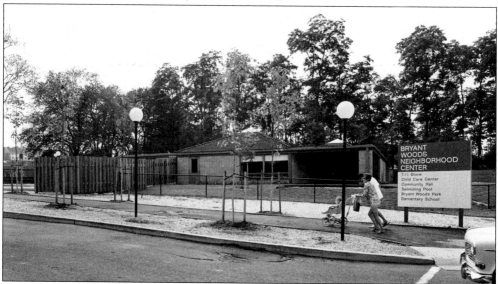

The elements of the neighborhood center were well thought out. The combination was designed to bring the community together with formal and informal gathering places. (Photo by Morton Tadder.)

Rouse and Rev. Barclay Brown helped break ground for the Wilde Lake Interfaith Center on Sunday, June 22, 1969. It was a milestone in the religious planning and thus the history of Columbia.

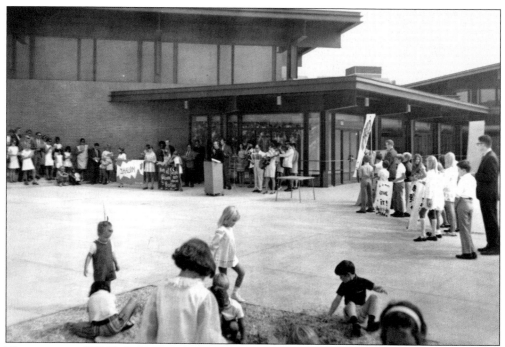

The opening of Wilde Lake Interfaith Center was truly cause for celebration. Several years of philosophical and physical planning preceded the opening. In an architectural statement, A. Anthony Tappe wrote, "This building creates a stimulating environment which permits and indeed encourages new patterns of worship and community life. In the final analysis, it falls to the people to create their spiritual community."

Jack in the Box in Wilde Lake Village Center was Columbia's first fast food chain, opening in 1971. It has been a Roy Rogers, Hardee's, and Kentucky Fried Chicken. Nothing beats the restaurant name-change trivia game for cocktail-party conversation.

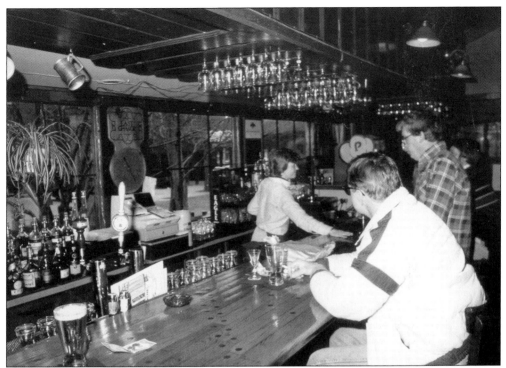

The winner of the name-change game is certainly the Last Chance in Oakland Mills. The name seemed to be the charm. It was the sixth try for that location. Long's Vineyard, The Crackpot, Phase Three, Barnums, Skipjack's, and Channing's Crab House all tried out the spot. The Last Chance was a popular place and had a strong following for its jazz band, but in 2004, the Last Chance abruptly served up its last burger and beer. As of this writing, the spot was awaiting a new restaurateur with a new idea willing to take a chance.

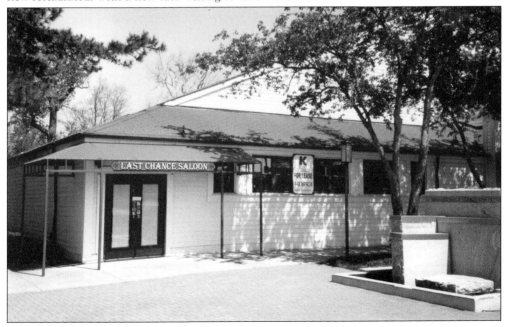

This is Long's Vineyard, the first in the long string of restaurants in the Oakland Mills location.

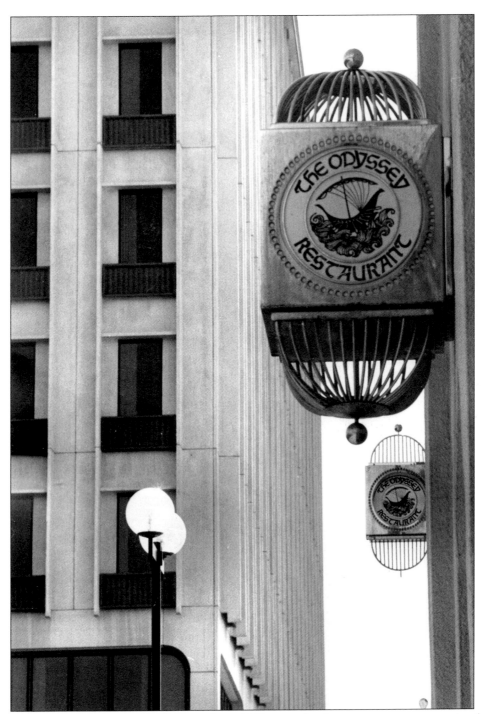

The Odyssey Restaurant, which opened in 1969, was the first restaurant to open in the Teacher's Building in Town Center. The goal was to offer a fine dining experience for Columbia's residents and to provide a reason for area residents to visit Columbia. Early ads stressed "the view, the dinner, the odyssey." Per Bacco followed Odyssey for a short time before Clyde's, now one of the oldest restaurants in Columbia, took over the space.

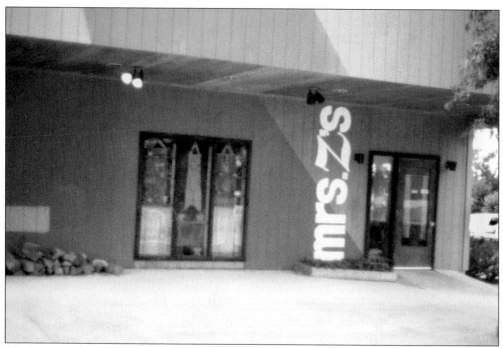

Mrs. Z's was a favorite community gathering spot known not only for its wonderful food but also for the warmth and spirit served up by the inimitable Peg Zabawa. Tragically, the restaurant burned in 1979 and never reopened.

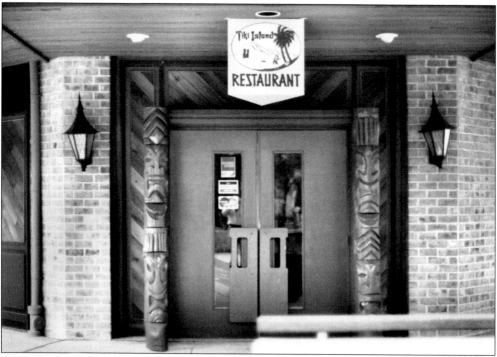

Tiki Island followed the Karras Beef House in Wilde Lake Village Center. Other restaurants that tried the space included HuNan and Avanti's.

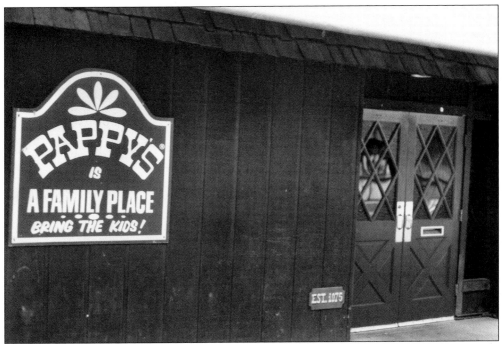

Long Reach Village Center had Pappy's in the mid-1970s. The menu featured family fare like burgers and pizza. The most expensive pizza was "The Woiks—Your Heart's Desire—the Kitchen Sink," and it cost $5.20 for the family size.

Marmaduke's Moustache was a 1970s late-night spot offering live entertainment and dancing. After it closed, Magic Pan and then Bennigan's tried the spot next to the cinema in Town Center. In 2003, the building was razed to make way for future development. (Photo by James Ferry.)

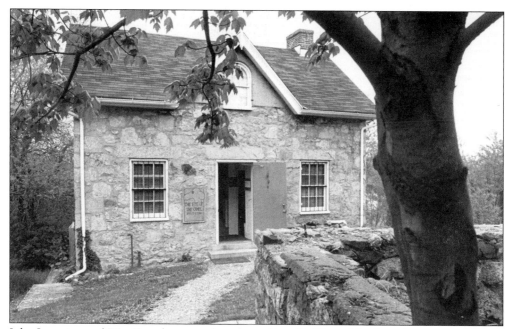

John Levering and Wes Yamaka opened an art studio called Eye of the Camel, turning a historic stone house into an early Columbia tradition. The silk-screen prints of Yamaka and woodcuts, sculpture, and oil paintings of Levering became such popular affordable art that when the Columbia Archives asked to borrow examples of their work for a retrospective exhibit in 1988, it was deluged with more 200 pieces.

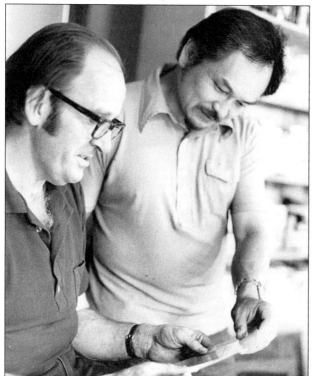

John Levering, left, and Wes Yamaka became art studio partners and friends. Both had come to Columbia, worked with Jim Rouse, and found ways to develop their talents, thereby realizing Rouse's vision that a successful community would allow for the growth of people.

Family, the sculpture that graces Wilde Lake Village Center, was designed by Pierre du Fayet. He was part of the Rouse team and interpreted Columbia's goals through public art. *Family* represents Columbia's goal to be a place that "was felicitous for the life and growth of the man, the woman and the family." Du Fayet's most important contribution to Columbia is *The People Tree*, the sculpture that has become the symbol of Columbia.

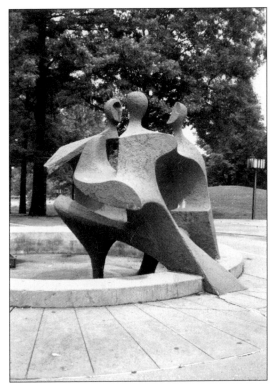

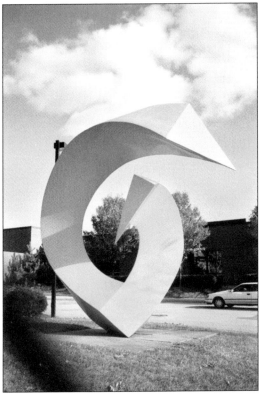

Reaching 10 feet into the air, the brightly colored *Caracol* enlivens Snowden Center on Oakland Mills Road. It is by Baltimore artist Mary Ann Mears, who has said this about the naming of the piece: "Caracol, a half turn performed by a horseman, is derived from the Spanish word meaning 'snail' or 'winding stair'. Caracol is also the name of a Mayan astronomical observatory at an archeological site in Mexico whose shape resembles a snail shell. My sculpture has a twisting feeling to it akin to the Spanish meaning and the observatory itself."

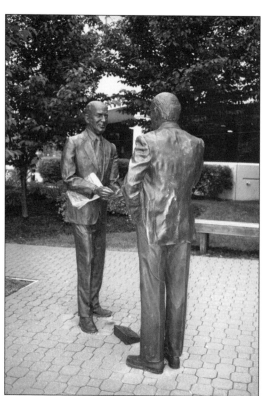

The cast-bronze, life-size figures of Rouse and his brother Willard enhanced the entrance to Symphony Woods Office Center on South Entrance Road before the sculpture was moved to its current, more visible location in Town Center. Willard's son was president of Rouse & Associates, a Philadelphia-based development company with Columbia offices in the Symphony Woods Center. The company commissioned the piece, titled *Dealings*, to honor the Rouse family.

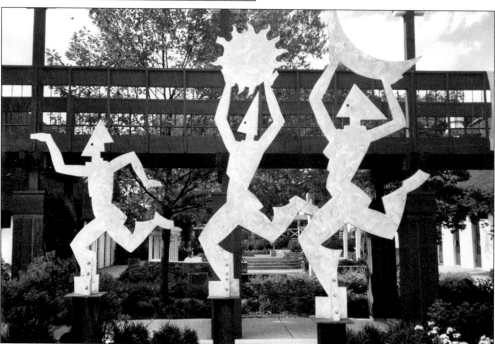

Celestial Serenade, by Rodney Carroll, was commissioned by Oakland Mills Community Association in honor of the village's 20th birthday. It is a salute to family and the passage of time.

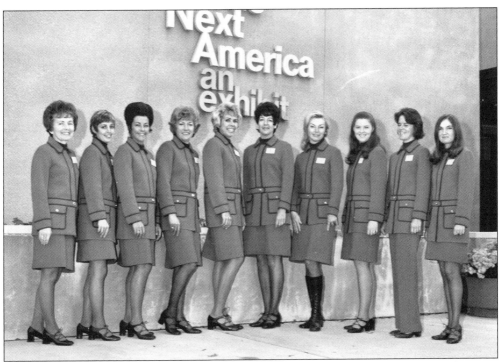

It was called the Next America. In the Exhibit Center, the promise of Columbia was presented in pictures, a slide show, and by knowledgeable hostesses. Pulitzer prize–winning novelist Michael Chabon describes what the Exhibit Center meant to him: "My earliest memories of Columbia are of the Plan. The Plan, in both particulars and spirit, was on display for all to see, in a little structure called the Exhibit Center."

The signage changed, but the message was the same. As Columbia grew, the exhibits and the slide show at the Exhibit Center changed to show actual buildings and the people who had already chosen to make Columbia their home. The center was a first stop for virtually everyone who moved to Columbia from 1967 until the center closed in 1989.

Some said
the best thing to do
with these barns
was burn them...
but something better happened

These photographs illustrated the story about Oakland Mills Village Center that appeared in *Columbia Today* in March 1970.

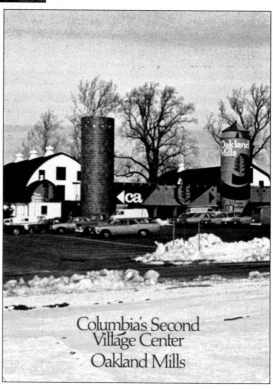

Columbia's Second
Village Center
Oakland Mills

Attracting businesses to Columbia was a vital part of the Columbia success story. Breaking ground for Hittman Associates, the first industry, brought local and state officials together. They are, from left to right, congressman Charles "Mac" Mathias; James Rouse; Fred Hittman, president of Hittman Associates; Charles Murphy, chairman of the Howard County commissioners; and Spiro Agnew, governor of Maryland.

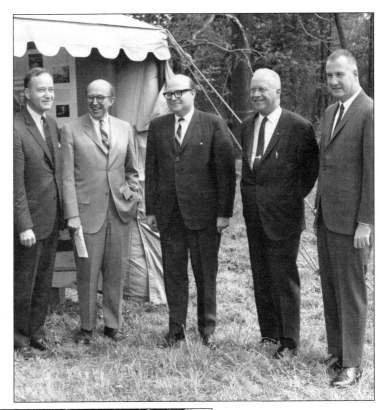

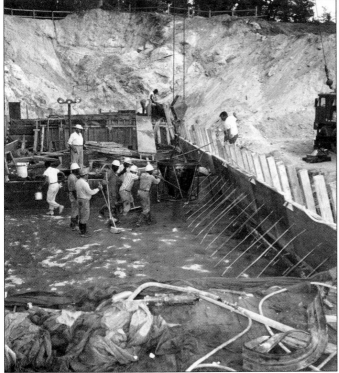

Construction of Wilde Lake dam went on day and night and was completed in fewer than three months. It is 200 feet wide and 27 feet high. The textured face of the dam was conceived by Mort Hoppenfeld and utilized tree bark in the molding of the concrete. (Photo by Max Araujo.)

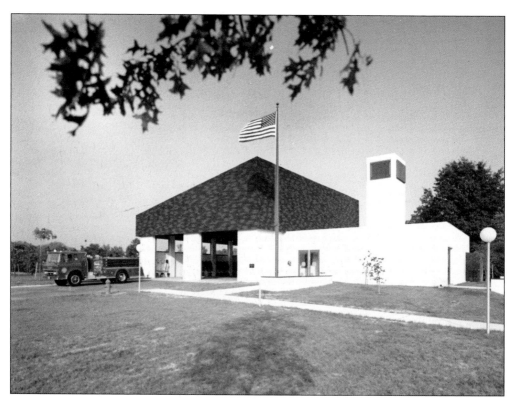

HRD worked closely with the volunteer fire department to create a plan to meet Columbia's public safety needs. The first fire house on Little Patuxent Parkway was designed by Frank Gehry's firm.

Lake Elkhorn, Columbia's third and largest lake, was dedicated on June 22, 1974. It was formed by damming Elkhorn Creek, which eventually feeds into the Little Patuxent River. Five acres of parkland surround the small pool below the concrete spillway, and a path that goes around the 37-acre lake is popular for walkers, joggers, and bikers.

The origin of the name of Town Center's bucolic park is obvious to Columbia's early residents, who knew that the Merriweather Post Pavilion within the park was built as the home of the National Symphony Orchestra. But the orchestra played for only a few years and, since then, the pavilion has hosted acts ranging from Elton John to Jerry Garcia and Metallica.

Columbia's first residents moved into the rental apartments in Bryant Gardens, shown here under construction in the beginning of May 1967.

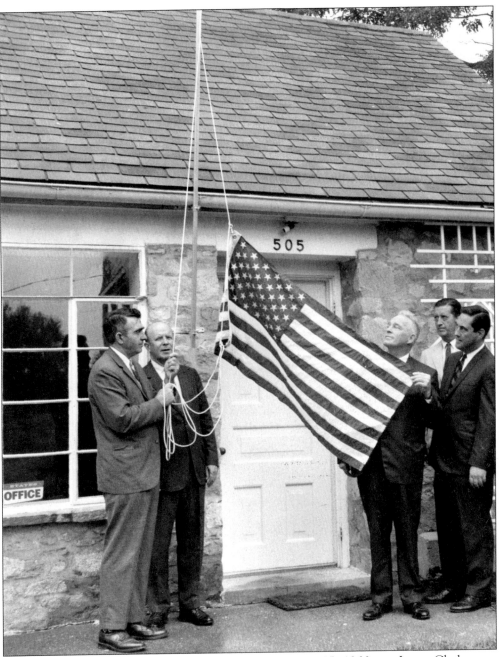

Raising the flag at Columbia's first post office on August 15, 1966, are James Clark, state senator; Willard Rouse, The Rouse Company vice-president and brother of Jim; Charles Miller, Howard County commissioner; John Shallcross, manager of land management for HRD; and Jack Slayton, Columbia Association manager. The building was one of the structures preserved in Columbia.

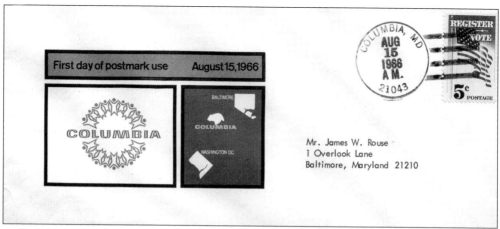

A first-day cover design to commemorate the opening of the post office incorporates the early Columbia logo with its string of people figures. The first first-day cover was mailed to President Lyndon Johnson. The one sent to James Rouse is part of the artifact collection at Columbia Archives.

North Entrance Road was the first entry into Columbia from Route 29. With the development of the Vantage Point neighborhood of Town Center, the road was realigned and renamed Vantage Point Road. (Photo by Morton Tadder.)

A unique indoor-outdoor pool in the Wilde Lake Village Center incorporated removable plexiglass inserts on the lower portions of the A-frame design. In the summer, it was open, but in winter, radiant heaters fired up enough heat to keep swimmers warm. The upper portion of the A-frame was left open to the sky. It didn't work quite as well as planned, and a more permanent enclosure was added shortly after the first winter.

This untitled granite sculpture at The Greens Apartments in Clary's Forest was designed specifically for the site by Don Shepherd. It was commissioned by the developer to reflect Columbia's intent to enhance human values.

The Hug, being lovingly touched by the sculptor, Jimilu Mason, was placed in Town Center in June 1987. The piece is dedicated to Mort Hoppenfeld. Mason said, "the work reflects Columbia as Mort envisioned it—a city of love, a city for lovers." The dedication ceremony was hosted by the joint donors of the sculpture and installation: Pat Kennedy representing Columbia Association, James Rouse representing the Enterprise Development Company, and Michael Spear representing The Rouse Company.

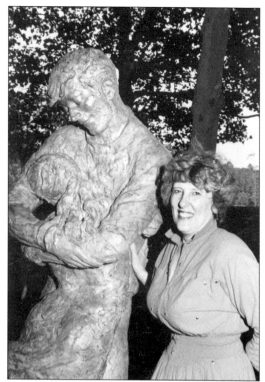

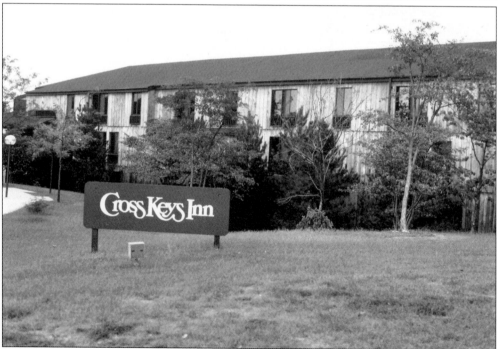

Columbia's first hotel was Cross Keys Inn. It boasted a fine restaurant that drew rave reviews in local newspapers when it opened in 1972; it became a popular spot. Many remember the long-time bartender George Papoulias.

In the early 1980s, the Cross Keys Inn doubled its capacity with completion of a 10-story tower and changed its name to Columbia Inn. In 1998, ownership of the hotel changed and it was renamed the Columbia Sheraton.

Four
CELEBRATING COMMUNITY

To build a better city is to work at the heart of civilization.
—Mort Hoppenfeld

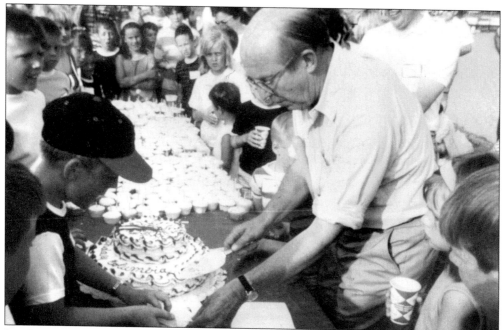

Jim Rouse cut the cake at Columbia's first birthday celebration and began a tradition that continued until his death. Columbia's pioneers began the celebration on Friday, June 21, 1968, with a bonfire and hot-dog roast for teenagers in a field behind the Wilde Lake Village Center. Festivities continued the next day with a picnic in Wilde Lake Park, a baseball game between the two Columbia teams (Barbers versus Sunoco), a puppet show, and free swimming, tennis, and dancing under *The People Tree*.

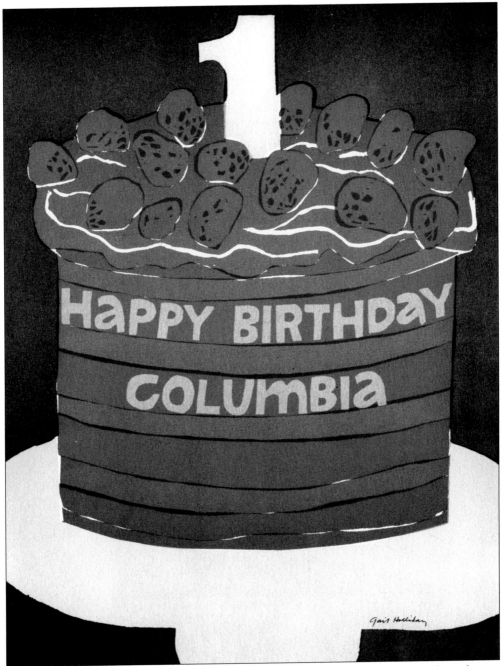

June 21 is Columbia's official birthday, and this poster by Gail Holliday was the first of many that commemorated the event. The Women of Columbia spearheaded the first year celebration, and since then, volunteers with support from The Rouse Company and Columbia Association have worked to mark the occasion in a special way each year.

Columbia started out as a small town. In 1968, the population was less than 2,000. Columbia staged a parade along Little Patuxent Parkway and capped the evening with fireworks—a small town celebration. Paraders passed by a shell of the Town Center's third building, the American City Building, or Two Wincopin, as it was then named. Columbia dignitaries, including, of course, its founder James Rouse, were on the reviewing stand.

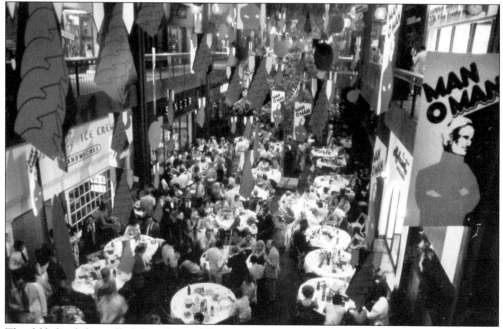

The fifth birthday called for a big celebration and included the first Ball in the Mall. Set-ups and snacks were provided at the BYOB affair that cost $8 per couple. Bands were set up in front of Hochschild Kohn and Woodies, and the party ran well into the night.

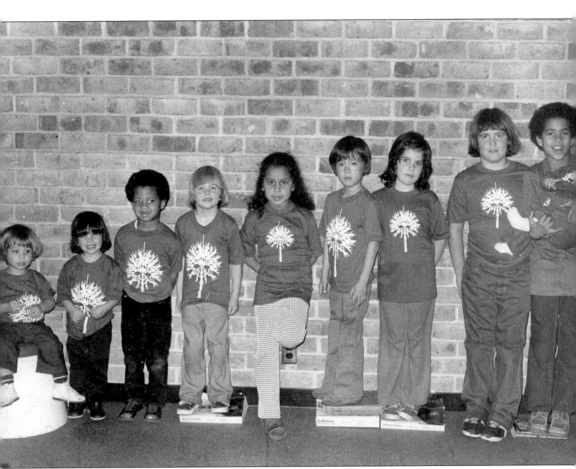

A picture of 10 children representing each of Columbia's 10 years appeared in the newspaper to publicize a city-wide meeting being held to help plan the 10th birthday celebration in 1977. The children are, from left to right, Scott Nudelman, Cara Caiazzo, Koti Hunter, Timothy Eagan, Lea Hamilton, Elliot DiSilva, Lauren Brown, Daniel Martin, Charles Russell—who was the first child born in Columbia—and in his arms, Ellen Barth.

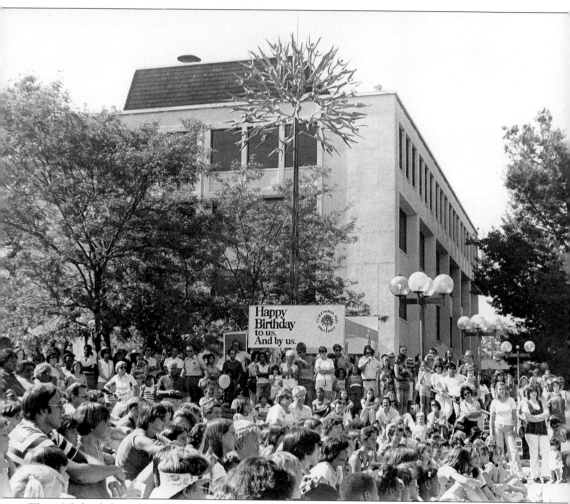

The 10th birthday was celebrated over a two-week period, culminating with a city fair at Lake Kittamaqundi. The city fair, complete with carnival, entertainment, and community booths, became a much anticipated yearly tradition coordinated by the Columbia Birthday Committee that lasted until 1994. In 1995, the Festival of the Arts replaced the city fair. One thing that never changed, however, was the cake-cutting tradition. (Photo by Fern Eisner.)

Special events marking the 10th birthday included a Gala Francais Ball in the mall to celebrate the establishment of a sister city relationship between Columbia and Cergy-Pontoise. Christian Gourmelen led the Cergy-Pontoise delegation and accepted a plaque from an unidentified representative of the chamber of commerce. (Photo by James Ferry.)

Judy and Mike Spear joined Jim Rouse at the podium at the Gala Francais. Mike Spear was the general manager of Columbia. Tragically, the Spears were killed in a private plane crash in 1990. (Photo by James Ferry.)

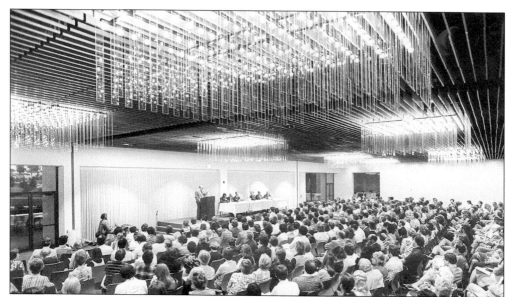

To mark the occasion of the 10th birthday, four members of the original Columbia work group and two key players, William Finley and Mort Hoppenfeld, returned to evaluate the vision and the reality of the city they helped to plan. More than 600 residents filled the Kittamaqundi Room at The Rouse Company headquarters and heard Hoppenfeld's message: "Whether Columbia continues to look forward depends on whether or not the people who remain will understand how difficult it is to keep alive a community. It takes money and it takes time." (Photo by Paul Abel.)

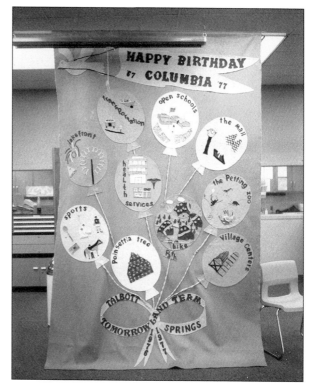

Talbott Springs Elementary School students made a big "birthday card" for Columbia's 10th birthday and sent it to The Rouse Company. It was displayed in the mall and in the company's headquarters.

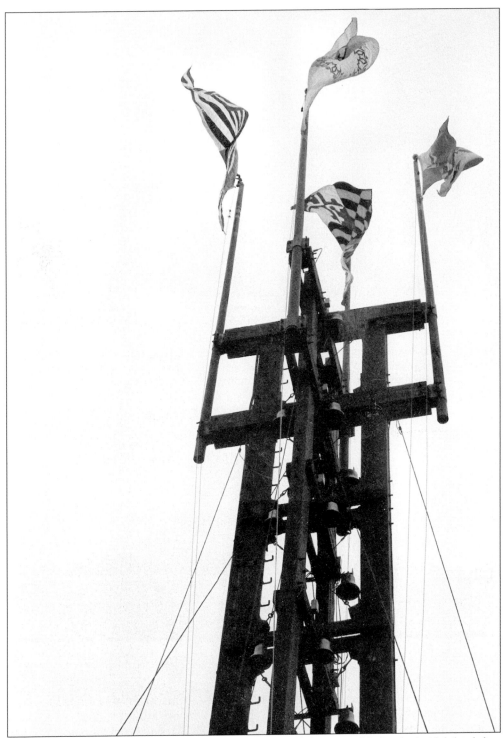

Ten carillon bells were installed in the wharf tower in celebration of Columbia's 10th birthday. They were a gift to Columbia from The Rouse Company and continue to bring music to the Town Center as they peal Westminster Chimes on the hour. (Photo by Fern Eisner.)

Astronaut John Fabian helped Columbia celebrate its 15th birthday and Columbia's adoption of the *Columbia* space shuttle. Columbia Council chair Pam Mack accepted a plaque containing a flag that was carried on the shuttle's first flight, a NASA shoulder patch, and the signatures of John Young and Robert Crippen, who flew the mission. The plaque is on display at the Howard County Central Library.

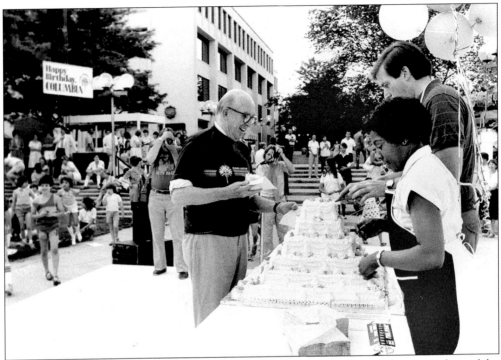

Rouse gets the first piece of cake served to him in 1984 by Maggie Brown, longtime chair of the Columbia Birthday Committee, and Doug McGregor, who represents The Rouse Company. (Photo by James Ferry.)

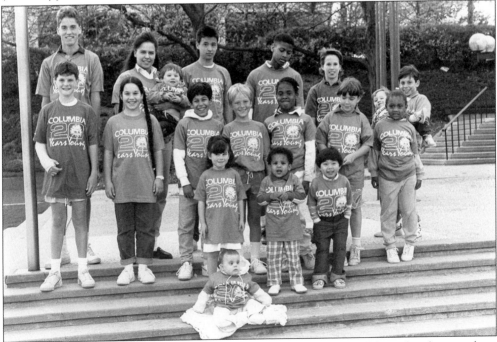

To mark the 20th birthday, Columbia looked back to the 10th and celebrated with a year-long calendar of events and a gathering of children from each of Columbia's 20 years.

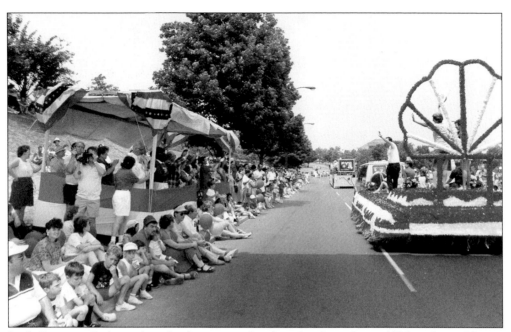

Little Patuxent Parkway doesn't often get to play the role of a traditional "Main Street," but in 1987, it was the parade route. As Columbians lined the curb, professional and homemade floats, school and kazoo bands, and other marchers, young and old, gave it that real hometown feel. (Photo by Ron Fedorczak.)

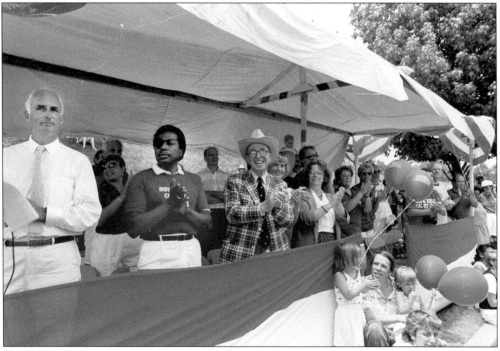

Pat Kennedy, president of Columbia Association; Vernon Gray representing Howard County Council; Jim Rouse and wife Patty; and Liz Bobo, Howard County executive, were among those in the reviewing stand for the 20th birthday parade. (Photo by Ron Fedorczak.)

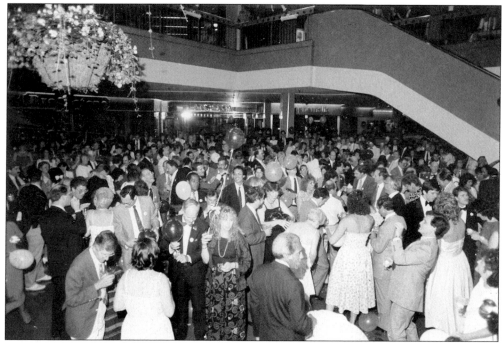

The theme of the 20th birthday Ball in the Mall was "That was Then . . . This is Now." Two bands and a DJ kept the capacity crowd on their feet. Among the giveaways ball-goers went home with were a glass and a split of champagne. (Photo by Ron Fedorczak.)

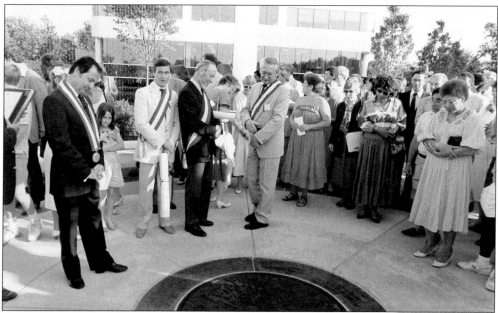

Columbia and Cergy-Pontoise, France, established a sister city relationship in 1977. Celebrating 10 years of the relationship and Columbia's 20th birthday, Columbia Association dedicated an official plaza, marked by large circular plaque embedded in the pavement. A French delegation was led by Christian Gourmelen, as it had been in 1977. (Photo by Ron Fedorczak.)

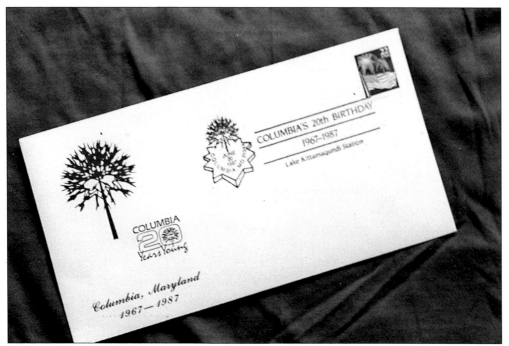

A special United States Postal Cancellation was created for the 20th birthday, and a Lake Kittamaqundi Station was set up in a booth at the annual city fair.

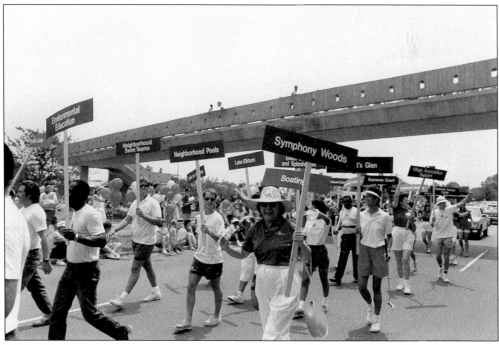

Columbia Association, created to enhance the quality of life for people in Columbia, struts its stuff in the 20th birthday parade. CA works in big and little ways to make Columbia special.

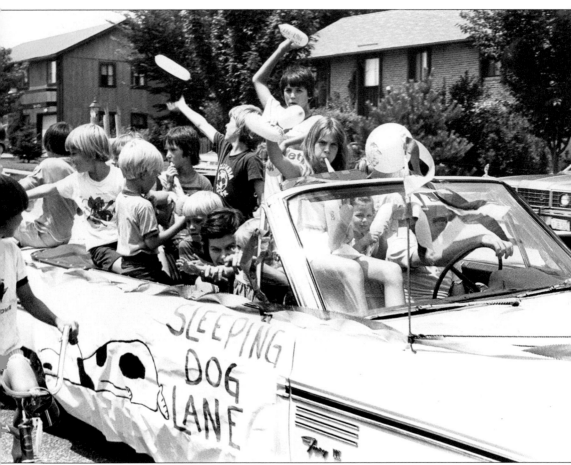

The Longfellow neighborhood parade holds the record for the longest running continuous 4th of July celebration. It's not just the homemade floats reflecting street names and community issues, or the kids on decorated bicycles, or the parading politicians that make this so "special"— it's that the entire neighborhood comes together as a community. (Photo by James Ferry.)

In 1980, the proposed closing of Longfellow Elementary School prompted the baby carriages and sign-carrying pregnant moms at the 4th of July parade.

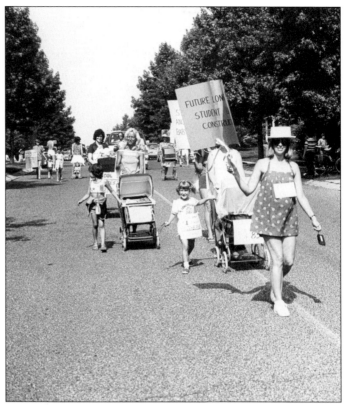

The Summer Lakefront Festival is a hallmark of Columbia. Since 1972, Columbia Association has sponsored nightly entertainment during July and August. Early schedules featured folk "sing-alongs," jazz concerts, and popular and classic movies. Special features for the season included Columbia's own barbershop singers, the New City Singers.

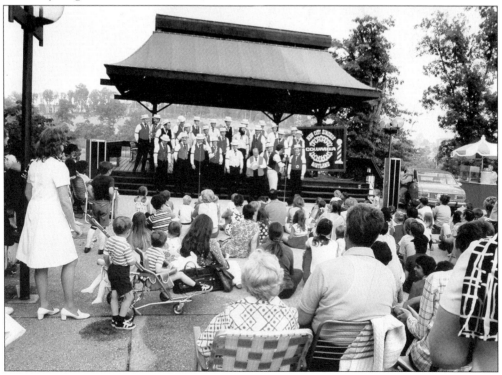

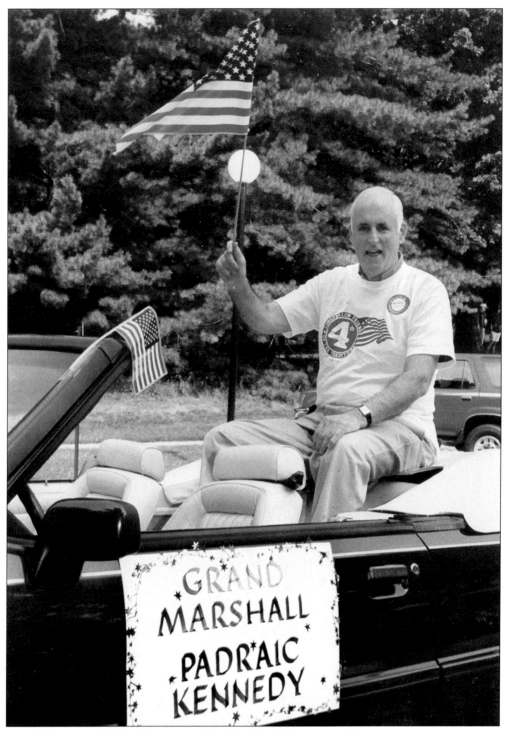

Columbia doesn't have a mayor, but Padraic (Pat) Kennedy, Columbia Association's president from 1972 to 1998, was often thought of that way. He dedicated his life to making Columbia a better place. The year he retired, he was grand marshall of the Longfellow 4th of July parade.

In 1975, Toby Orenstein put together a young troupe of singers and dancers for one performance at Merriweather Post Pavilion. Soon, the group became the Young Columbians. They traveled all over the country and, on February 21, 1977, they performed at a White House state dinner hosted by President Carter.

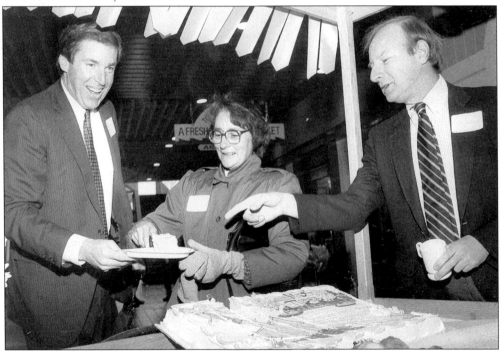

Ruth Keeton and Lloyd Knowles, right, join Rouse Company vice-president Doug McGregor for a cake-cutting celebration marking the re-opening of a renovated Harper's Choice Village Center in 1986. Keeton represented Harper's Choice on the Columbia Council from 1971 to 1973 before serving on the Howard County Council for 14 years. She resigned from public office in 1989, suffering from Alzheimer's Disease. At the time, Rouse said of her, "She's the supreme model of a citizen in pursuit of making her community the best it ought to be."

The *Prairie Ship Columbia* was launched in 1989. Sculptor Naj Wikoff designed the artwork, and then volunteers cut, stitched, and erected the giant sails on an open lot near the Mall in Columbia. It was a symbol of the Columbia Voyage, Columbia Forum's public planning process to reexamine Columbia's goals and set an agenda for the future.

Columbians responded enthusiastically to Columbia Association's idea to re-do Town Center Plaza and sell personalized pavers to raise funds to refurbish *The People Tree*. Searching for one's brick became a popular activity. The program proved so successful that CA has continued to occasionally offer the pavers so that Columbians new and old can have their place in the shadow of Columbia's symbol.

The model home park in the Huntington neighborhood in Kings Contrivance opened in June 1979 and drew crowds of Columbians. The opening of new neighborhoods was often cause for celebration as Columbians moved from one village to another. With housing ranging from apartments to single-family homes in varied price ranges, Columbia offered the opportunity to move without moving away. (Photo by James Ferry.)

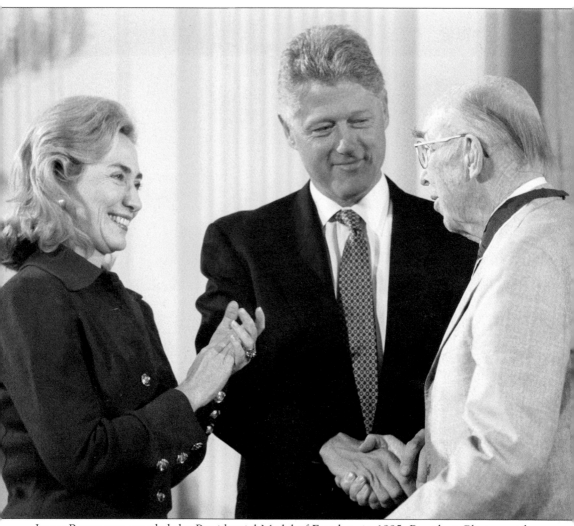

James Rouse was awarded the Presidential Medal of Freedom in 1995. President Clinton said, "If every American developer had done what James Rouse has done with his life, we would have lower crime rates, fewer gangs, less drugs. Our children would have a better future." (Photo by David Hobby.)

Laying the cornerstone at the rededication of the Owen Brown Community Center are Andy Stack and Pearl Atkinson-Stewart, who have both devoted much of their lives to serving their village. Columbia's governance structure of volunteer village boards and the Columbia Council/Columbia Association Board of Directors is a key element of Columbia's goal to be a place for people to grow. The list of residents who have made a difference in the community is long and could be the focus of another book.

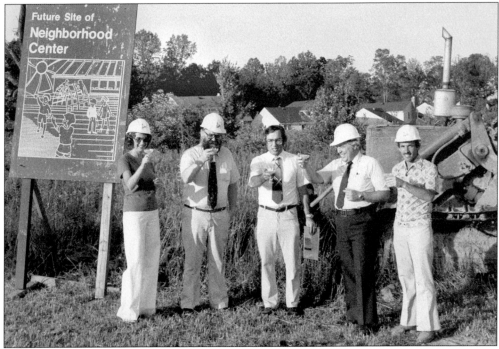

The Hickory Ridge Village Board and the contractor toast the groundbreaking for the Hawthorn Neighborhood Center. They are, from left to right, Dean Lindblad, Jim Dailey, an unidentified contractor, Harry Geissenhoffer, and Fred Berko.

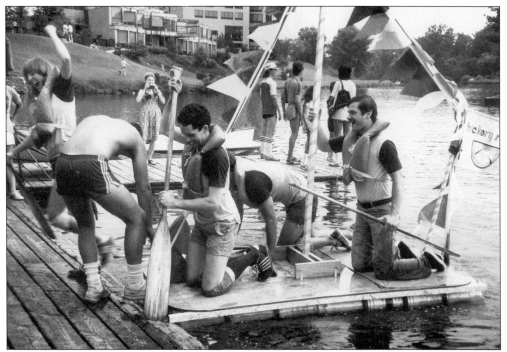

It's not all work for those who choose to be involved in Columbia governance. In 1985 and 1986, village community volunteers participated in some friendly competition as part of the birthday celebrations.

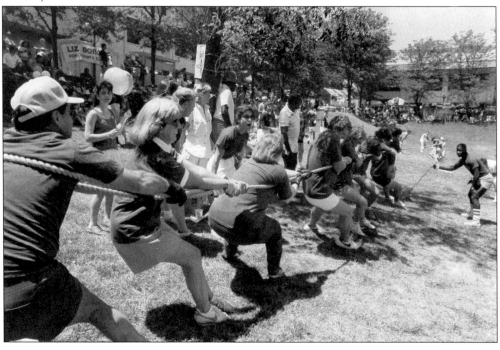

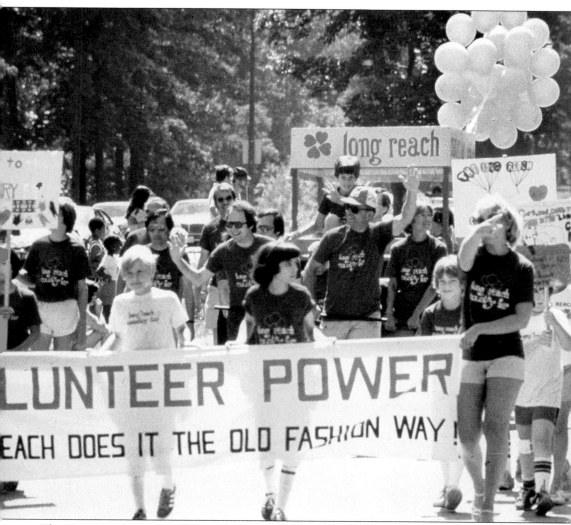

The Long Reach Country Fair, an annual event, is another example of the community spirit that contributes so much to the success of Columbia. Central to the concept of building community are the ideas of civic engagement and volunteerism. The Columbia Association helped to encourage volunteerism by establishing the Columbia Volunteer Corps in 1990 and played an instrumental role in creating the Volunteer Center Serving Howard County in 2001. The Volunteer Center incorporated the Columbia program and expanded the mission and the services to encompass all of Howard County.

Columbia flies the flags of Spain and France for two weeks in July when students from Tres Cantos, Spain, and Cergy-Pontoise, France, take part in the high school exchange of Columbia's Sister Cities Program.

This is good advice from Columbia's founder. Mrs. Patty Rouse sports a commemorative tee-shirt during the 30th birthday celebration in 1997.